LONDON STYLE

LONDON

Streets Interiors Details

STYLE

Jane Edwards
EDITOR
Angelika Taschen
PHOTOS
Simon Upton

TASCHEN

HONG KONG KÖLN LONDON LOS ANGELES MADRID PARIS TOKYO

To stay informed about upcoming TASCHEN titles, please request our magazine
at www.taschen.com/magazine or write to TASCHEN, Hohenzollernring 53,
D-50672 Cologne, Germany, contact@taschen.com, Fax: +49-221-254919.
We will be happy to send you a free copy of our magazine which is filled with
information about all of our books.

© 2008 TASCHEN GmbH
Hohenzollernring 53, D-50672 Köln
www.taschen.com

Original edition: © 2001 TASCHEN GmbH
© Art Donald Judd Estate/VG Bild-Kunst, Bonn 2008, for the work by Donald Judd
© VG Bild-Kunst, Bonn 2008, for the work by Alexander Calder
Edited by Angelika Taschen, Cologne
Cover design by Angelika Taschen, Claudia Frey, Cologne
Simon Upton is represented by The Interior Archive, London
Photos on pp. 10–37 by Julian Anderson, London
Texts edited by Petra Frese, Dortmund
Editorial coordination by Ursula Fethke, Cologne
Lithography by Horst Neuzner, Cologne

Printed in China
ISBN 978–3–8365–0777–6

CONTENTS SOMMAIRE INHALT

Today sees London riding a wave of economic optimism and resurgent creativity, but historically it has always been a city in a state of perpetual change and regeneration. Over 2,000 years it has grown out from the banks of the River Thames to become the sprawling metropolis it now is, dominating the South-East of England. There was never a grand planning vision for London, unlike Paris or Rome. Instead it has evolved organically, with waves of sporadic property development dictated by the ebbs and flows in the economy. The city started life as a centre of trade and finance and continues to be one. This constant regeneration has created an ever-changing landscape. Particularly the modernising Victorians were keen on getting rid of old churches and buildings in the name of progress. The result is either a vibrant city of unexpected contrasts, or a dispa-

KALEIDOSCOPIC LONDON

Jane Edwards

Aujourd'hui, Londres est portée par une vague d'optimisme économique et de résurgence de créativité. Toutefois, historiquement, elle a toujours été en mutation et en régénération perpétuelle. Elle a surgi des berges de la Tamise il y a plus de 2 000 ans pour devenir la métropole gigantesque qu'elle est aujourd'hui, dominant le sud-ouest de l'Angleterre. Contrairement à Paris ou à Rome, elle n'a jamais connu de grands projets d'urbanisation. Elle a évolué de façon organique, par vagues sporadiques de développement immobilier dictées par les marées montantes et descendantes de l'économie. Cette régénération constante a créé un paysage urbain changeant continuellement. Au nom du progrès, les Victoriens en mal de modernisation rasèrent à tire-larigot les églises et les bâtiments jugés trop anciens. Selon le goût de chacun, le résultat est une ville de contrastes débordante de vie ou un bric-à-brac sans

London hat das neue Jahrtausend mit großem Optimismus begonnen. Die Wirtschaft boomt. Die Kunst- und Designszene blüht. Die Geschichte zeigt, dass die Stadt, vor rund 2 000 Jahren am Ufer der Themse gegründet, stets ein Talent dafür hatte, sich wechselnden Bedingungen anzupassen und immer für alles Neue offen zu sein. Heute ist die im Südosten Englands gelegene Metropole eines der mächtigsten Handels-, Finanz- und Kulturzentren der Welt. Anders als in den Weltstädten Paris oder Rom hat es nie eine konsequente Stadtplanung gegeben. In jeder Epoche wurde – entweder im Überschwang wirtschaftlicher Hochstimmung oder nach großen Katastrophen – viel, aber aufs Geratewohl gebaut. Unter Queen Victoria wurden alte Kirchen und Gebäude im Namen des Fortschritts abgerissen, um dem Stadtbild ein neues Gesicht zu geben. Das Ergebnis ist eine Stadt voller unerwarteter Kontraste, auch wenn einige Kritiker

rate hotchpotch of architectural styles, depending on your point of view. But a wonderful side effect of this architectural diversity is abundant choice – only imagination can limit how you live in the metropolis.

Like many large cities, London is a series of insular villages. It is possible to cross from one side of the street to the other and enter a completely different world. The long-standing artistic and Bangladeshi communities that live side by side around the Brick Lane area in the East End are a moment away from the throbbing financial heart of the City, while Islington is known for its elegant flat-fronted Georgian terraces, favoured by the New Establishment, which stand within yards of sprawling concrete public housing.

Your village and architecture of choice can say an awful lot about the kind of person you

queue ni tête de styles architecturaux. Néanmoins, cette diversité architecturale a un effet secondaire bénéfique: l'abondance du choix. Il n'y a que l'imagination qui puisse entraver la manière que chacun a de vivre Londres.

Comme de nombreuses autres grandes villes, Londres est composée de villages à la personnalité bien marquée. Il suffit parfois de traverser une rue pour changer complètement d'univers. Les communautés artistiques et bangladaises qui se partagent depuis longtemps le quartier de Brick Lane ne sont qu'à deux pas du cœur financier de la City. Les élégants alignements de façades du 18e d'Islington, favorisé par le New Establishment, côtoient des kilomètres de H.L.M. en béton.

Dans cette ville, votre village et votre architecture de prédilection en disent long sur la personne que vous êtes. Un simple code postal peut inspirer des conclusions hâtives. SW6 (Fulham) évo-

den stilistischen »Mischmasch« beklagen. Doch zu Londons ganz eigenem Zauber gehört auch die Vielfalt alter und neuer Architektur.

Wie viele andere Metropolen besteht London aus einer Ansammlung von kleinen, eigenständigen »Dörfern«, die sich zu einem großen Ganzen zusammenfügen. Dass die Stadt seit Jahrhunderten andere Kulturen assimiliert hat, wird schnell deutlich, denn oft muss man nur auf die andere Straßenseite gehen, um in eine völlig andere Welt einzutauchen. Die Hinterhöfe der Brick Lane im East End, in der die seit langem etablierte bengalische Gemeinde friedlich neben jungen Künstlern wohnt, liegt nur ein paar Schritte entfernt von den Prestigebauten des Börsenviertels. Direkt neben den eleganten georgianischen Backsteinreihenhäusern von Islington, das vom Neuen Establishment geschätzt wird, findet man triste Sozialwohnungsblöcke.

are in this city. Assumptions are easily made on the strength of a postcode alone. An SW6 (Fulham) postcode conjures up images of 30-something "smug-marrieds" (a term coined by Helen Fielding in her "Bridget Jones" novels); W11 (Notting Hill) is heaving with "trendier than thou" trustafarians (they have a private income but look like ragamuffins); and EC1 (Clerkenwell) is populated by that archetypally 90s phenomenon, the urban loft-dweller. But things are not quite that simple. The continually shifting sands of fashion mean that these interpretations are also in a state of flux. Thus, for example, while Notting Hill in the 80s was considered the epitome of multicultural bohemianism, today it is being called "the new Chelsea", and the run-down areas of Hoxton and Shoreditch in the east are now "the new Notting Hill". Chelsea's King's Road meanwhile,

que immédiatement des images de jeunes trentenaires «fièrement mariés» – une expression d'Helen Fielding dans ses journaux de «Bridget Jones».

W11 (Notting Hill) grouille de banquiers rastaquouères dans le vent (ils sont pleins aux as mais ont l'air de va-nu-pieds). EC1 (Clerkenwell) est l'antre de ce phénomène typique des années 90, le «lofteur urbain». Mais les choses ne sont pas aussi simples. Les sables mouvants de la mode rendent ces interprétations des plus fluctuantes. Dans les années 80, Notting Hill était synonyme de bohème cosmopolite. Aujourd'hui, on l'appelle «la nouvelle Chelsea» tandis que les quartiers délabrés d'Hoxton et de Shoreditch, à l'est, sont devenus «les nouveaux Notting Hill». De son côté, la King's Road à Chelsea, qui était l'équivalent d'Hoxton dans les années 60, incarne désormais l'establishment.

In welchem Stadtteil und mit welchem Baustil man lebt, verrät viel über einen; allein die Postleitzahl scheint einiges auszusagen. Mit einem SW6 (Fulham) »post code« assoziiert man die »smug marrieds«, die selbstzufriedenen jungen Ehepaare Anfang dreißig – ein Begriff, den Helen Fielding in ihren »Bridget-Jones«-Büchern geprägt hat.

In W11 (Notting Hill) tummeln sich die »trendy trustafarians« (Leute mit privatem Einkommen und sorgfältig stilisiertem Notstandslook). EC1 (Clerkenwell) repräsentiert ein Phänomen der 90er Jahre, die Loftbewohner. Doch in einer schnelllebigen Zeit mit ständig wechselnden Trends ist nichts von Dauer. Notting Hill – noch in den 80er Jahren das Epizentrum des multikulturellen Chic – wird inzwischen als »neues Chelsea« gehandelt. Die lange vernachlässigten Vororte Hoxton und Shoreditch im Osten Londons gelten als das »neue Notting Hill«, während an

which in its sixties heyday was the equivalent of Hoxton, is now bona fide establishment. As the 90s media and marketing phenomenon "lifestyle" becomes more pervasive and egalitarian, the resolutely fashionable Londoner has been forced to look further afield and be even more inventive to stay ahead of the crowd. There is hardly an area in central London which hasn't been "discovered", which leaves only one way to go. It's odds on that suburbia will be the next Big Thing.

London is an extraordinary city – endlessly creative and imaginative, vibrant and contradictory, multiculturally unique, paradoxically sophisticated and iconoclastic, sometimes eccentric, but always intriguing. This book is a window on the private worlds of a handful of Londoners whose homes reflect the city in all its spirited diversity.

A mesure que le phénomène médiatique et commercial du «dis moi comment tu vis et je te dirai qui tu es» des années 90 se répand et se démocratise, le Londonien résolument branché est contraint de regarder toujours un peu plus loin et de redoubler d'imagination pour se démarquer de la masse. Il n'y a plus un mètre carré du centre de Londres qui n'ait été «redécouvert», si bien qu'il ne reste qu'une seule voie à suivre. Il y a fort à parier que la banlieue sera le prochain endroit où il faut être vu! Londres est une ville d'une créativité et d'une imagination sans cesse renouvelées, énergique et contradictoire, d'un multiculturalisme unique en son genre, paradoxalement sophistiquée et iconoclaste, parfois excentrique mais toujours intriguante. Ce livre est une fenêtre ouverte sur les mondes privés d'une poignée de Londoniens dont les intérieurs reflètent la ville dans toute sa diversité inspirée.

Chelseas King's Road, einst Hochburg der Swinging Sixties, heute das respektable Bürgertum wohnt.

»Lifestyle«, in den 90er Jahren das Zauberwort der Medien und Marketing-Profis, ist mittlerweile für jedermann zugänglich. Wer sich da als imagebewusster Londoner von der breiten Masse distanzieren will, muss sich etwas einfallen lassen. Vor allem gilt es, flexibel zu sein und neues Terrain zu erforschen. Folglich gibt es kaum ein Viertel in der Londoner Innenstadt, das nicht schon einmal »entdeckt« worden ist. Schon zeichnet sich eine neue Tendenz ab: »The next Big Thing« sind vermutlich Londons Vororte. London ist eine unvergleichliche Stadt – kosmopolitisch und kultiviert, kreativ und innovativ, manchmal widersprüchlich und exzentrisch, aber nie langweilig. Dieses Buch ermöglicht den Blick in eine Handvoll Wohnungen, die London in seiner ganzen anregenden und lebendigen Vielseitigkeit widerspiegeln.

"I loved to watch couples brazenly kissing on the grass of St. James's Park; or working-class mothers on their doorsteps in Lambeth showing encouragement to their little boys fighting a boxing match; or a young City clerk on the tombs of an urban cemetery, taking advantage of his lunch hour to expose his pink torso to the sun."

Frank Horvat, photographer

«J'aimais voir les couples se bécotant sans vergogne sur le gazon de St. James's Park; les mamans sur les portes des maisons ouvrières de Lambeth, lançant des cris d'encouragement à leurs petits garçons engagés dans un match de boxe; ou le jeune ‹City clerk›, installé entre les tombes d'un cimetière urbain et profitant de l'heure du déjeuner pour exposer au soleil son torse rose.»

Frank Horvat, photographe

»Ich liebte es die Paare zu beobachten, die sich auf dem Rasen des St. James's Park ungeniert küssten, oder die Mütter vor den Türen der Arbeiterhäuser in Lambeth, die ihre kleinen Jungen bei Boxkämpfen laut anfeuerten, oder auch den jungen ›City clerk‹, der zwischen den Grabsteinen eines städtischen Friedhofs sein Lunch einnahm und dabei seinen rosigen Oberkörper der Sonne preisgab.«

Frank Horvat, Fotograf

STREETS
Rues Straßen

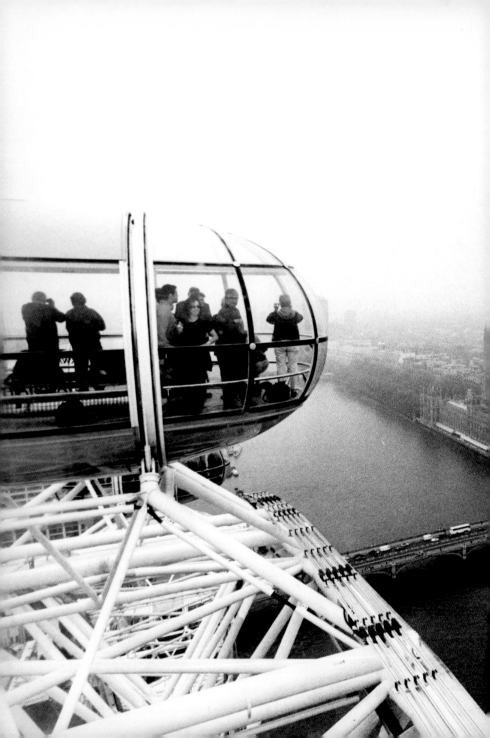

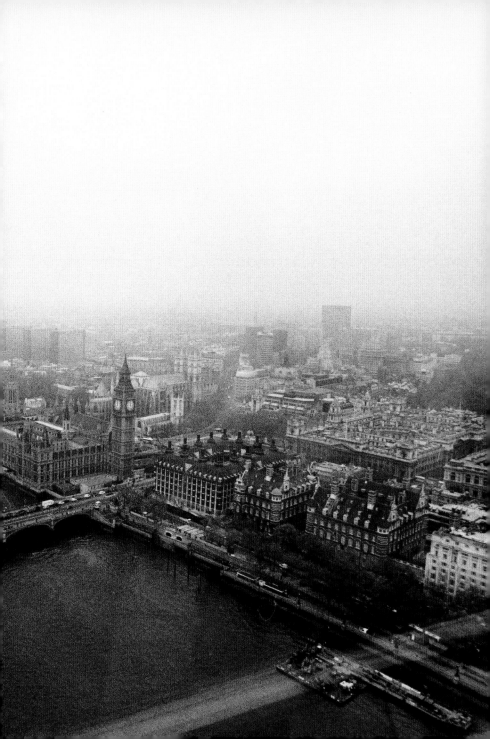

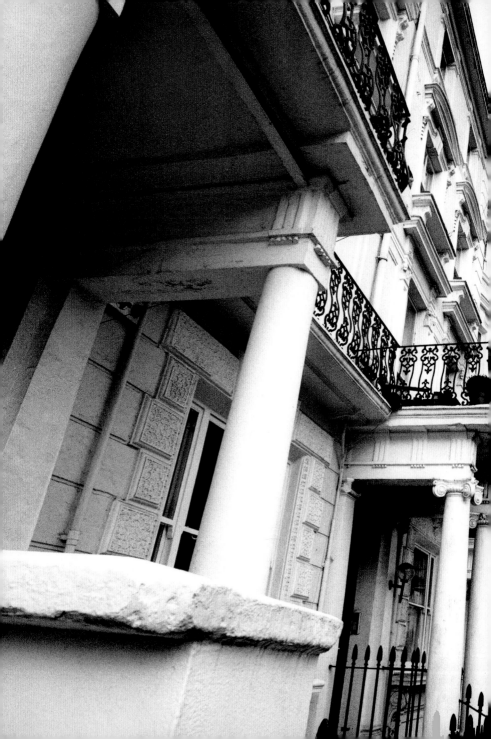

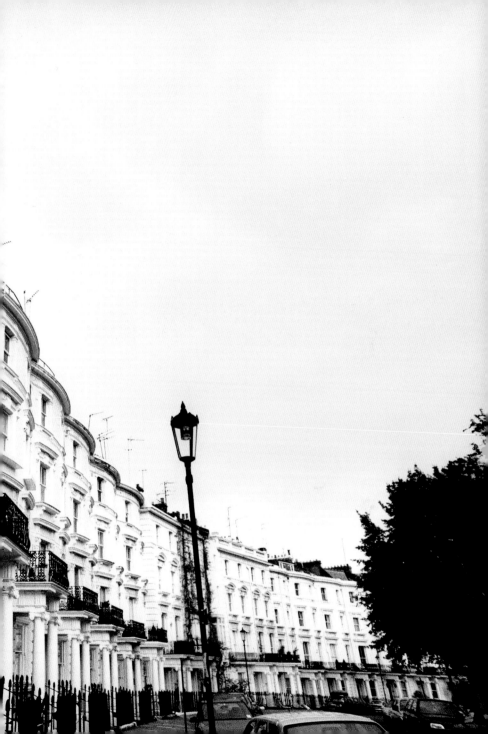

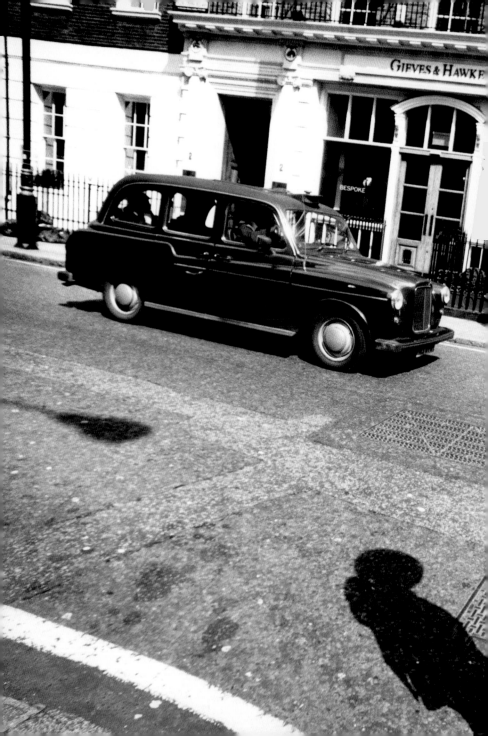

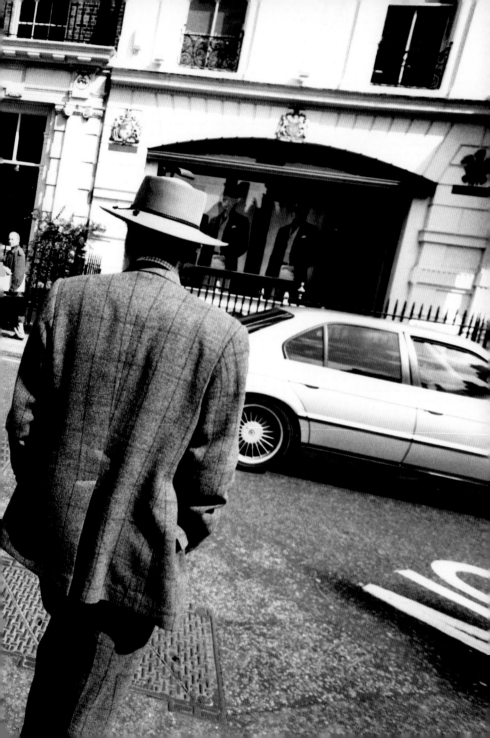

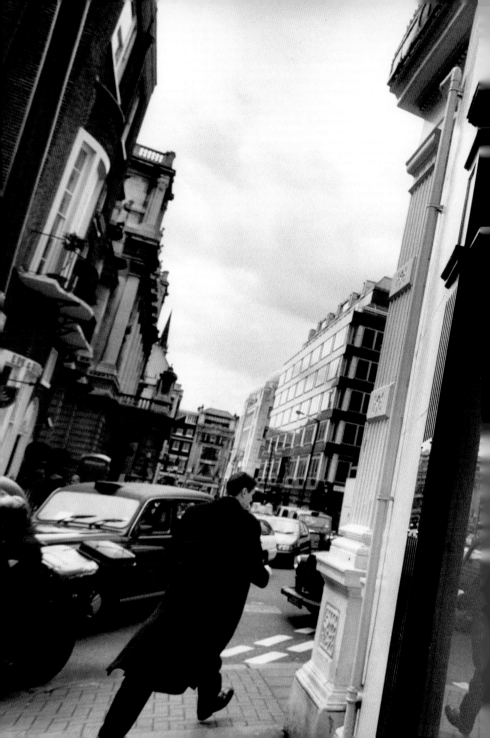

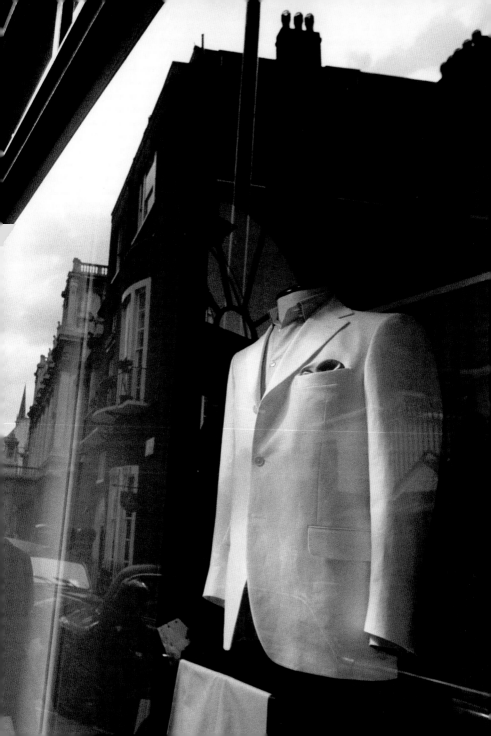

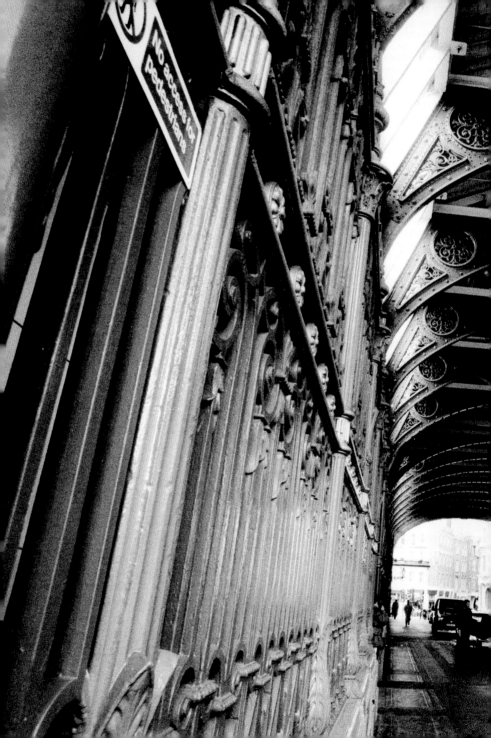

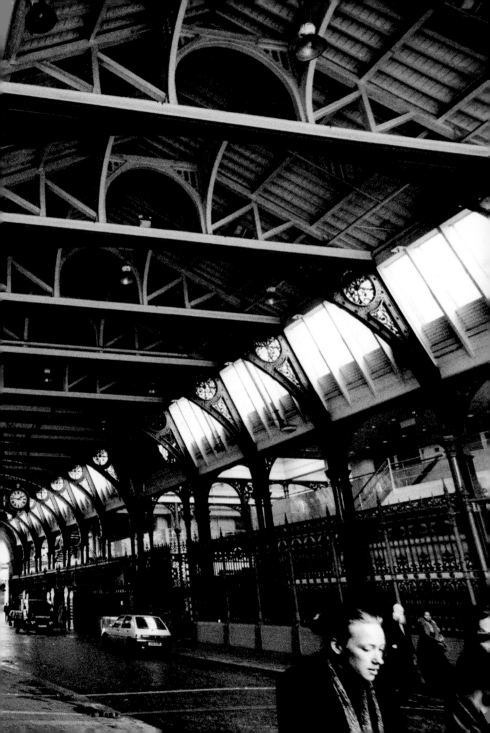

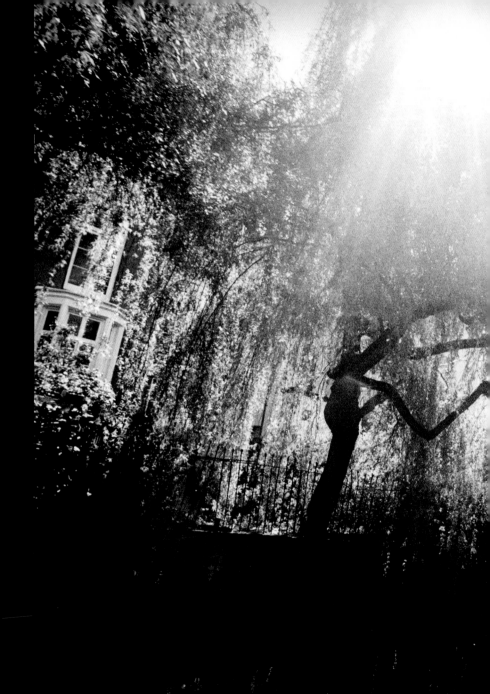

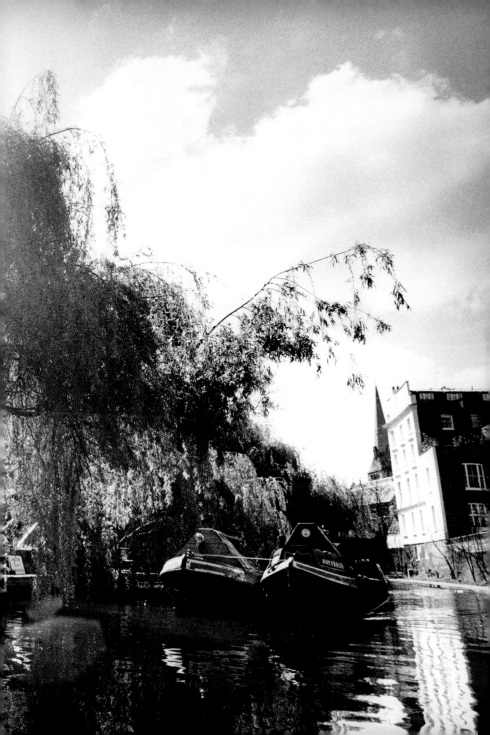

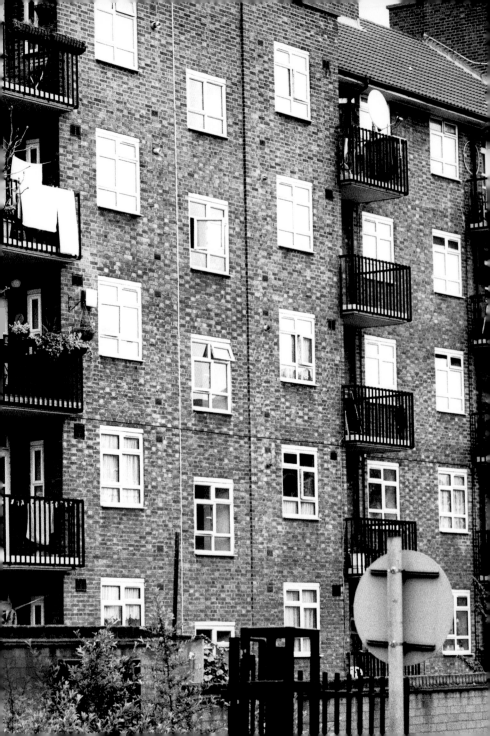

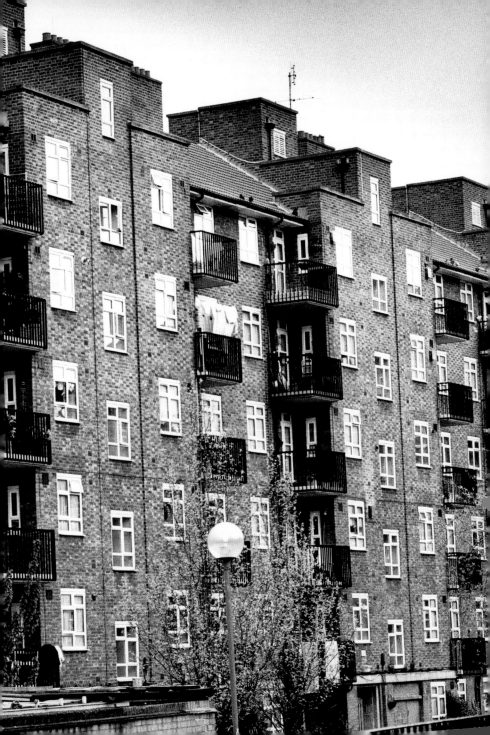

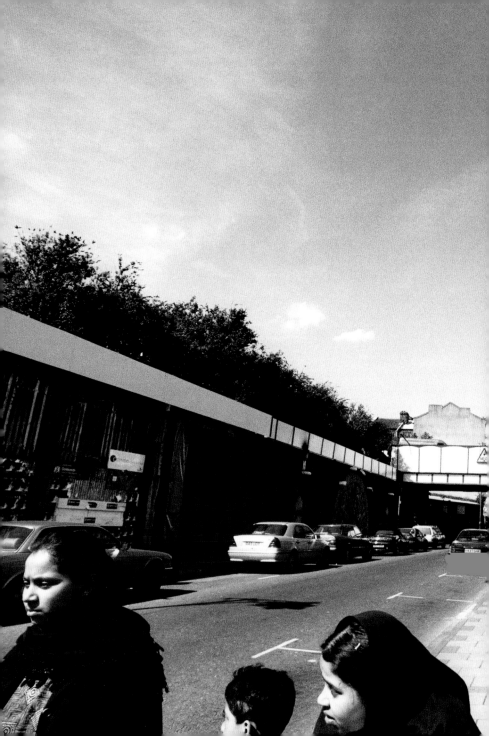

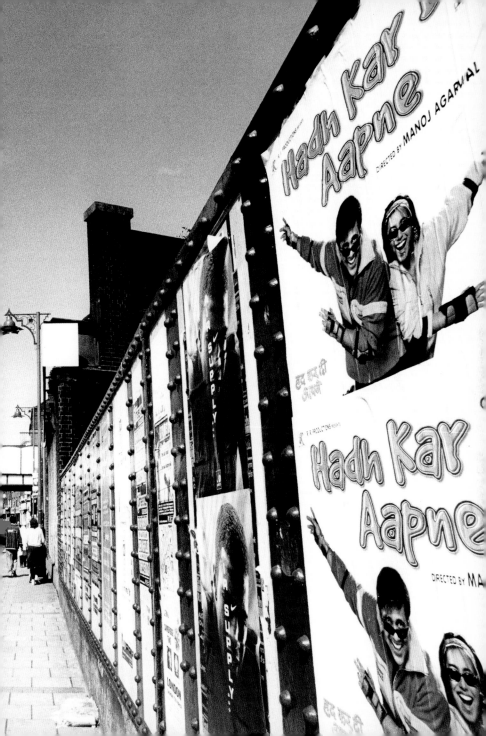

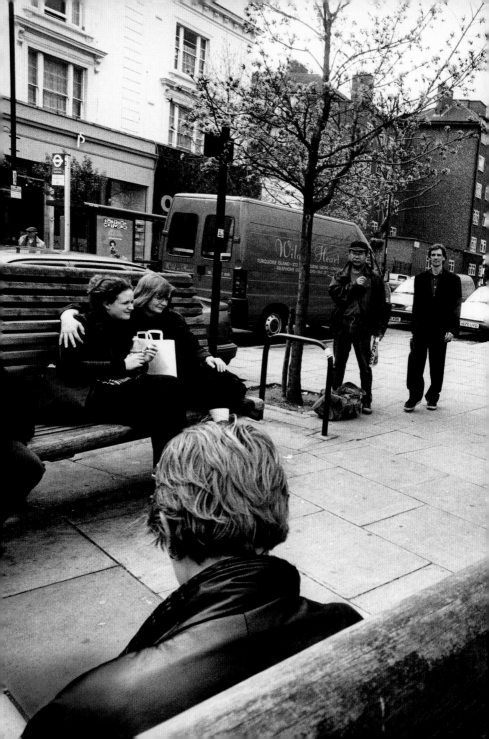

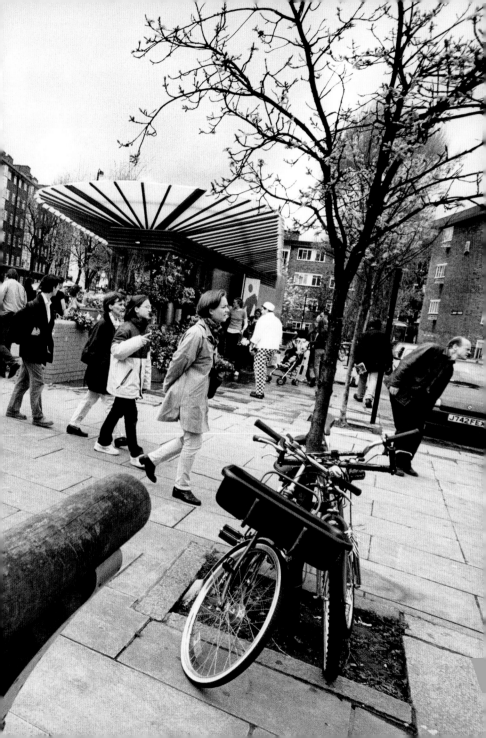

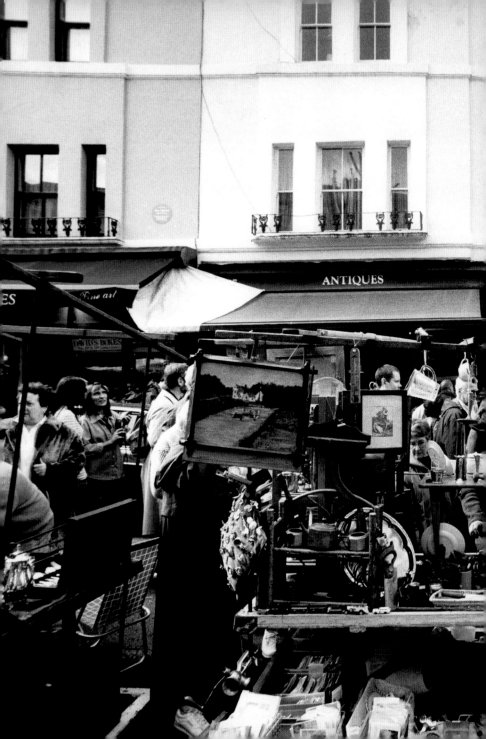

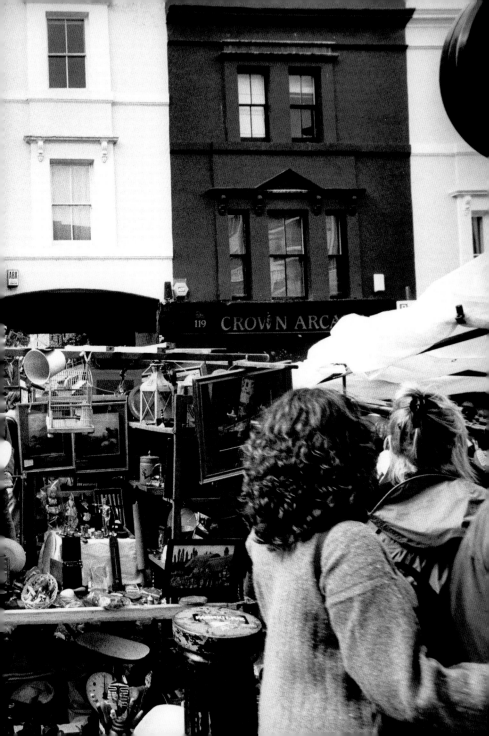

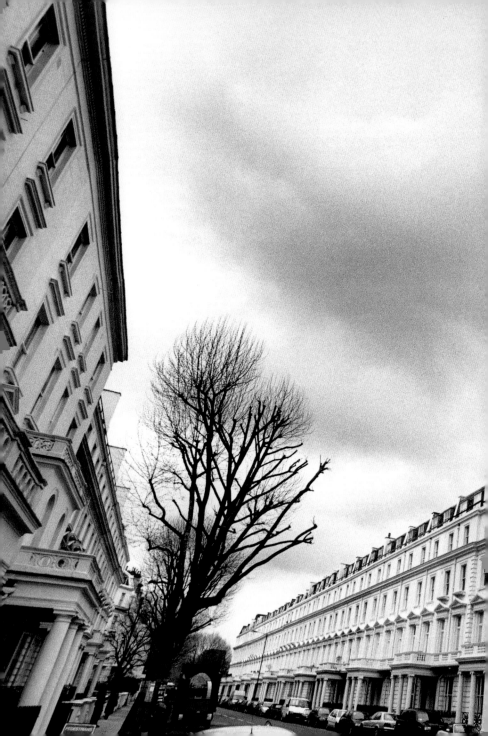

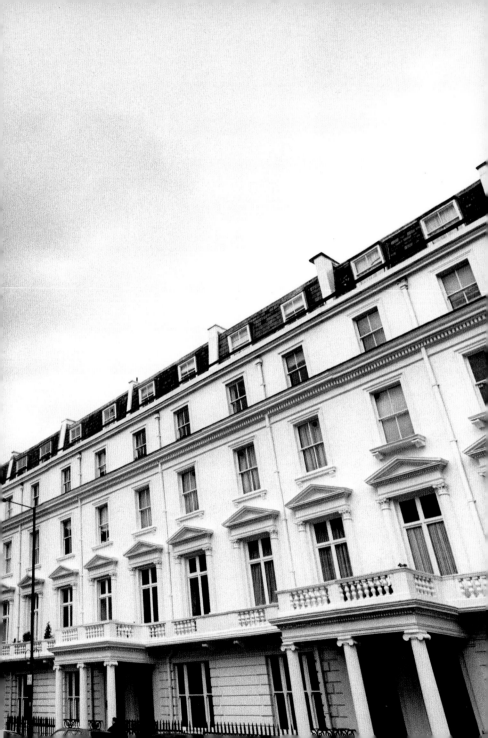

12/13 The Thames, Houses of Parliament and Big Ben seen from the London Eye. *La Tamise, le Parlement et Big Ben vus du London Eye.* Blick vom London Eye auf die Themse, das Parlament und Big Ben.

14/15 Notting Hill, London W11.

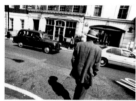

16/17 Saville Row, London W1.

18/19 Burlington Gardens, London W1.

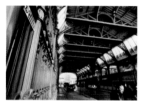

20/21 Smithfields Market, London EC1.

22/23 Grand Union Canal, London NW1.

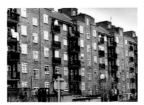

24/25 Vauxhall, London SE1.

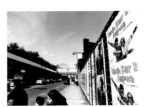

26/27 Brick Lane, London E1.

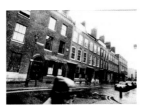

28/29 Fournier Street, London E1.

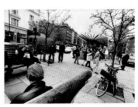

30/31 Westbourne Grove, London W11.

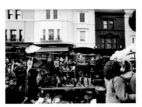

32/33 Portobello Road, London W11.

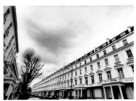

34/35 Arundel Gardens, London W11.

"So this was London at last, and nothing gave me more pleasure than strolling around my new posses-
sion all day. London seemed like a house with five thousand rooms, all different; the kick was to work out
how they connected, and eventually to walk through all of them."

Hanif Kureishi, *The Buddha of Suburbia*, 1990

«Londres, c'était donc ça et rien ne me faisait plus plaisir que de me balader toute la journée dans mon
nouveau territoire. Londres ressemblait à une maison de cinq mille pièces, toutes différentes les unes des
autres; ce qu'il y avait d'excitant c'était de découvrir comment les pièces étaient reliées et en fin de
compte, de les traverser toutes.»

Hanif Kureishi, *Le Bouddha de banlieue*, 1990

»Dies war also London. Nichts machte mir mehr Spaß, als den ganzen Tag in meinem neuen Revier her-
umzuschlendern. London kam mir vor wie ein Haus mit fünftausend verschiedenen Zimmern; der Reiz lag
darin zu entdecken, wie die Zimmer miteinander verbunden waren, und sie allmählich alle zu durchlaufen.«

Hanif Kureishi, *Der Buddha aus der Vorstadt*, 1990

INTERIORS

Intérieurs Interieurs

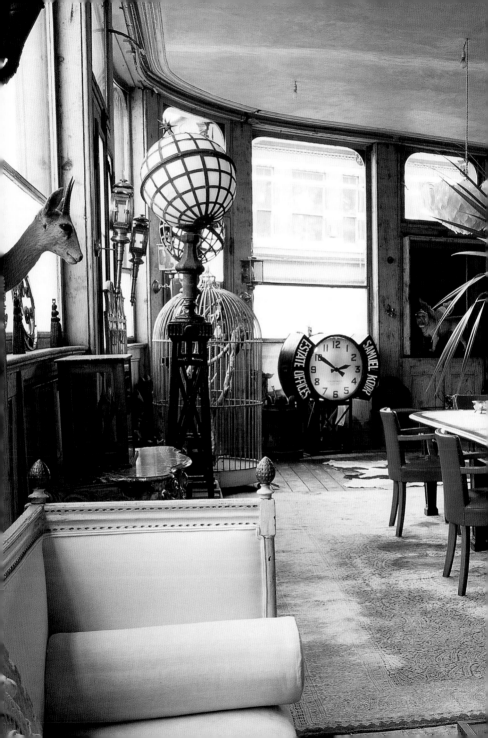

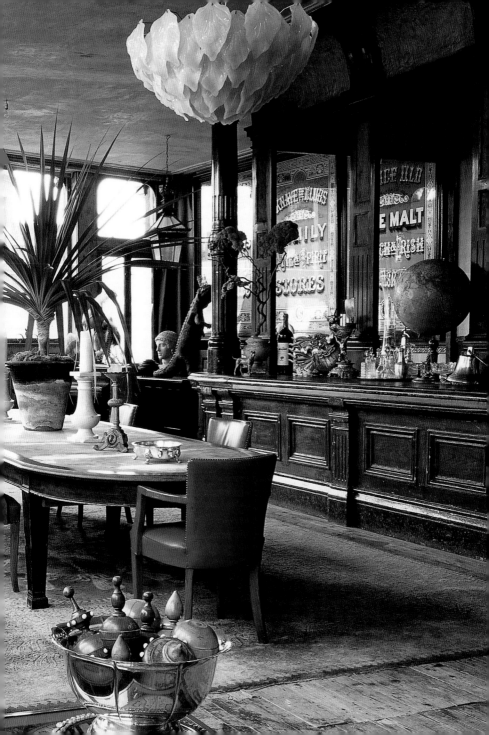

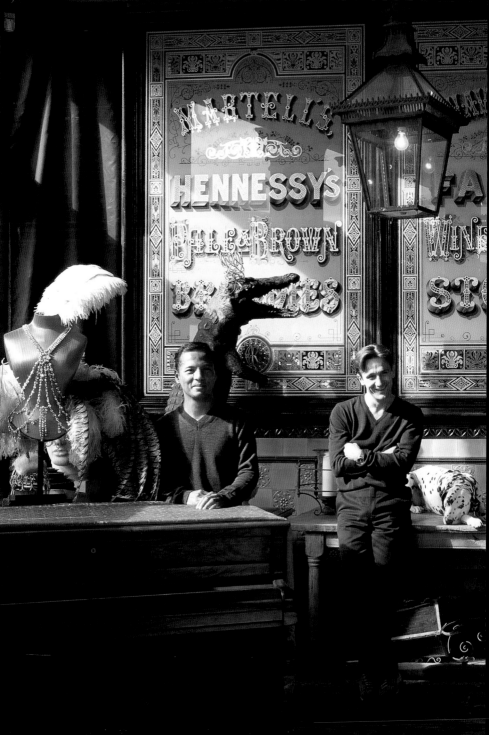

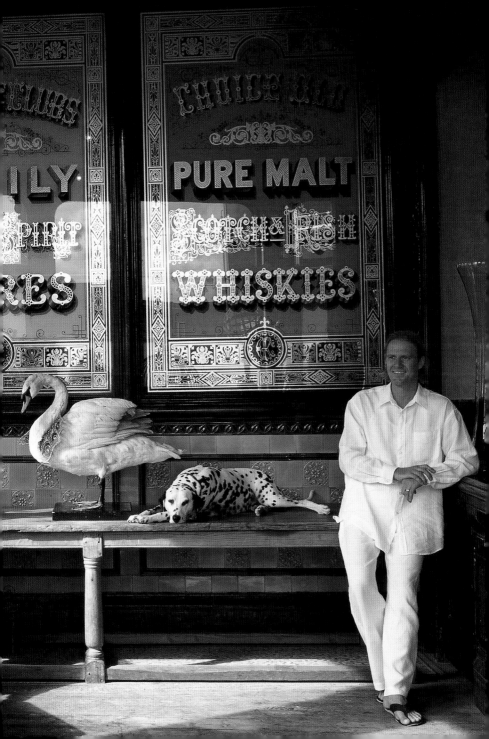

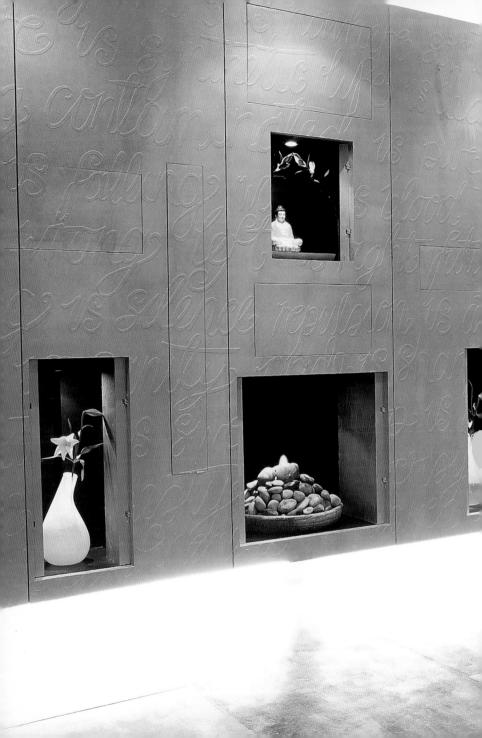

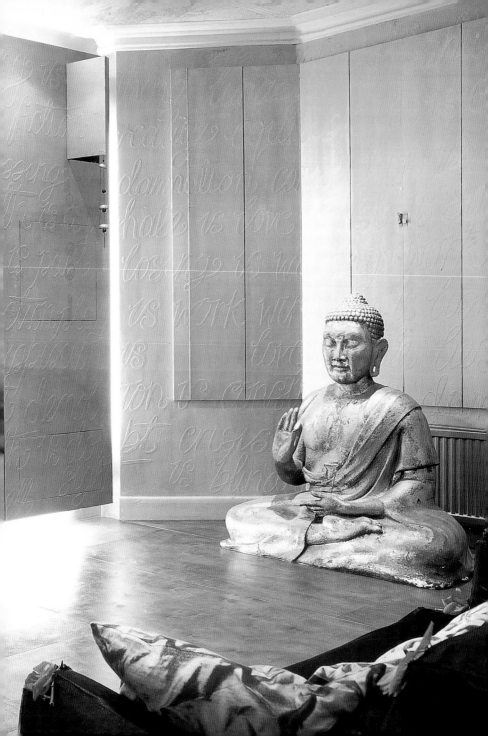

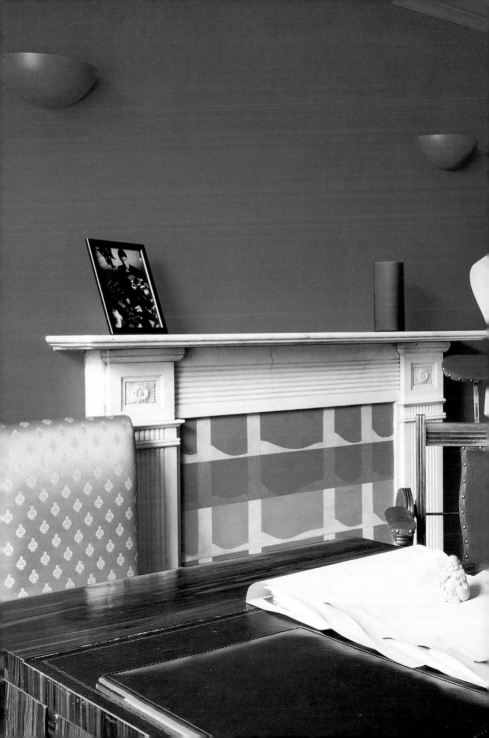

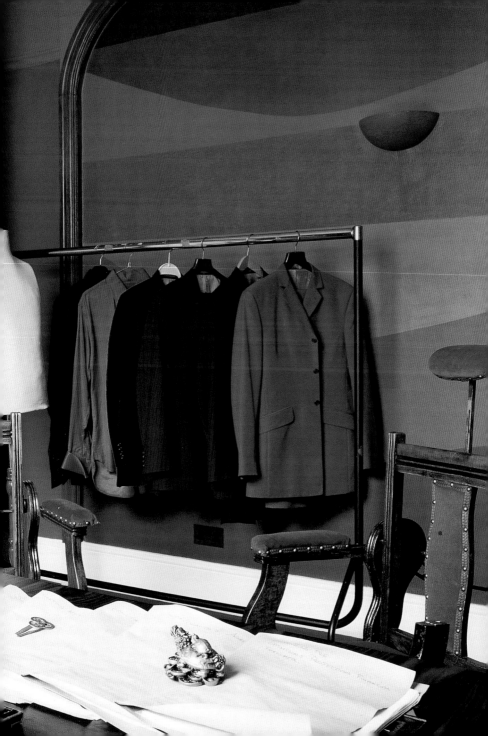

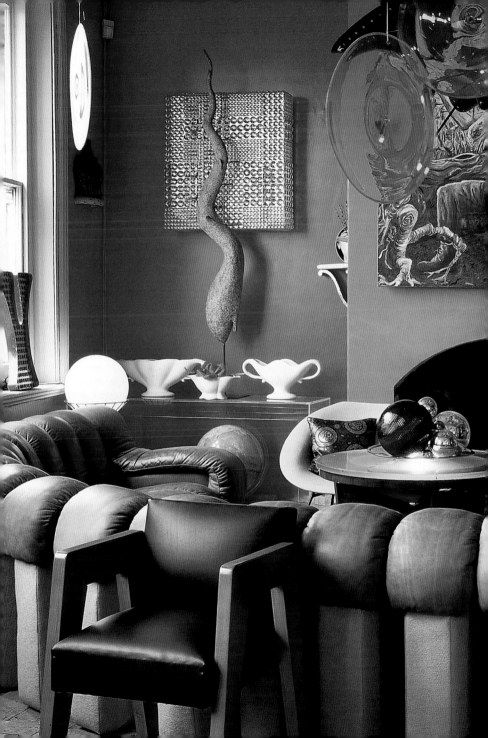

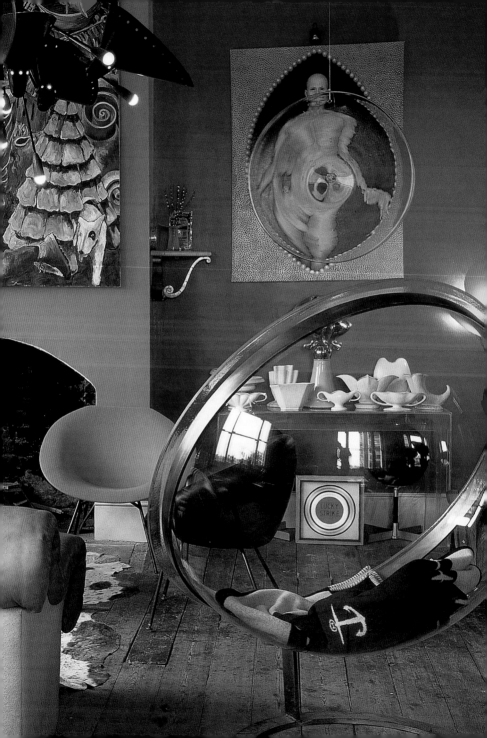

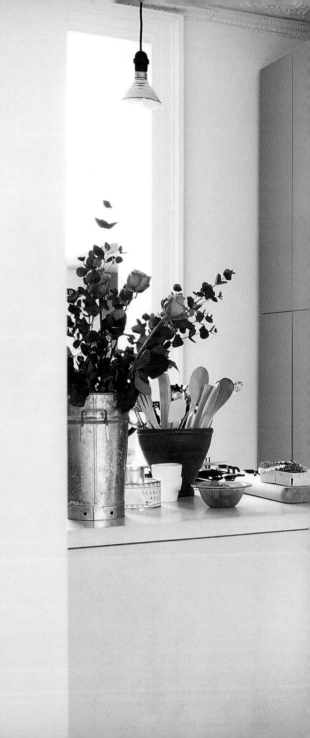

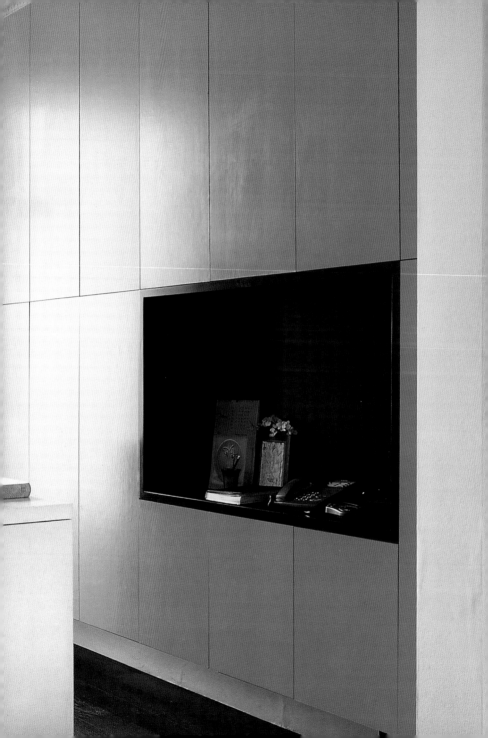

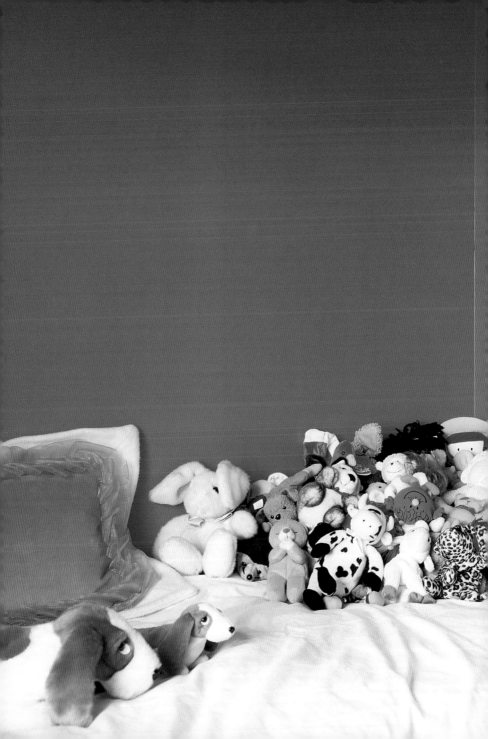

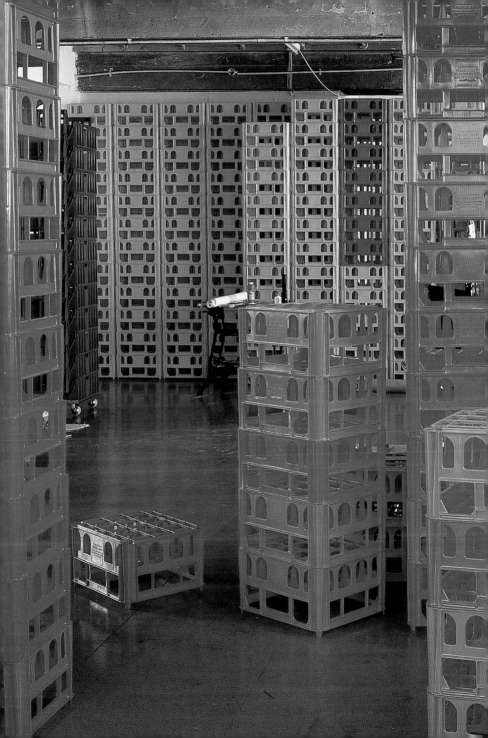

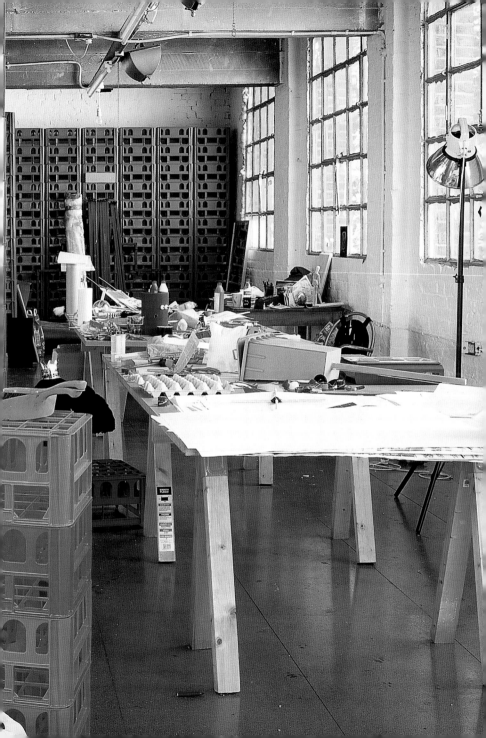

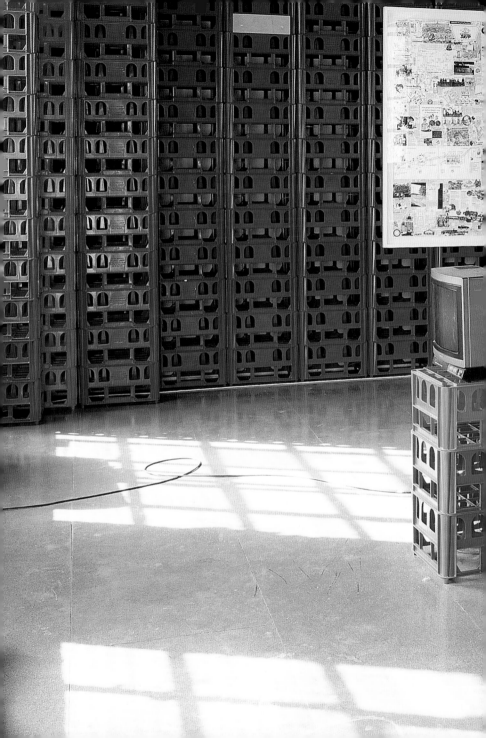

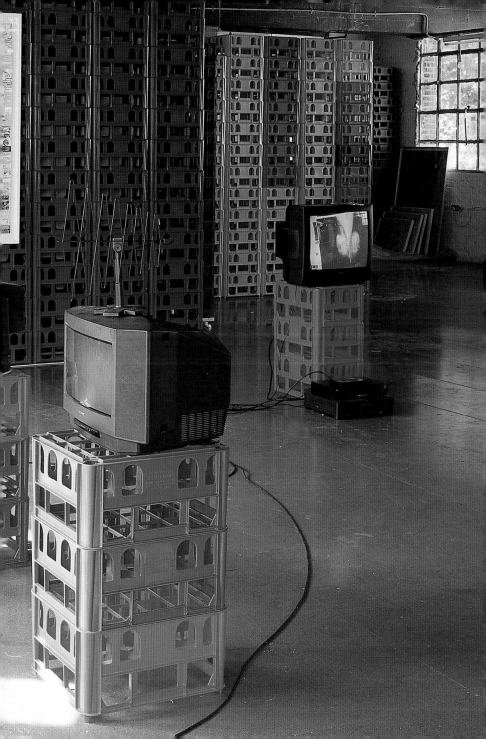

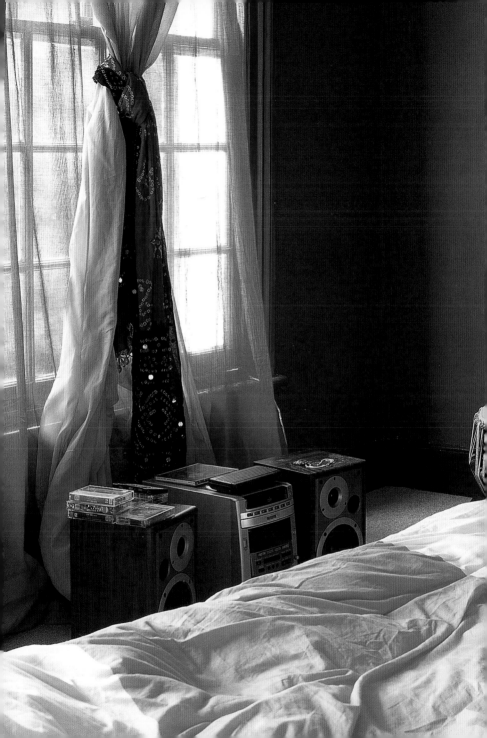

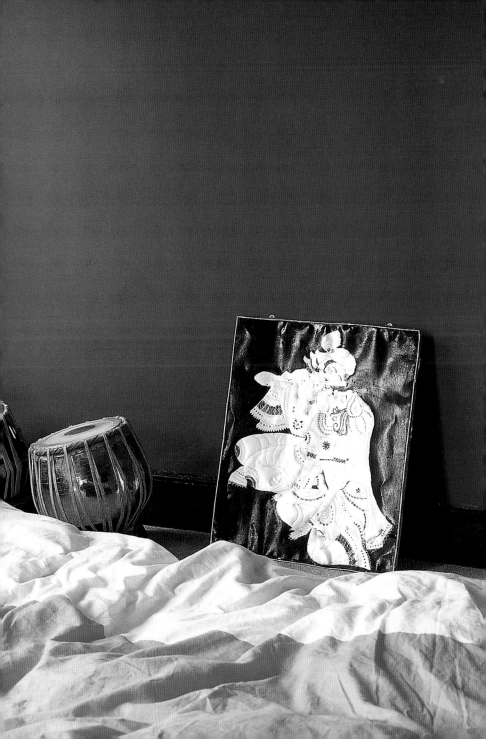

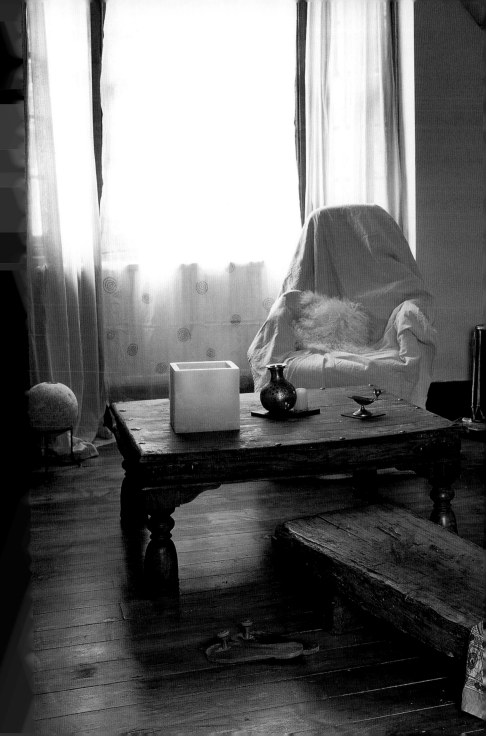

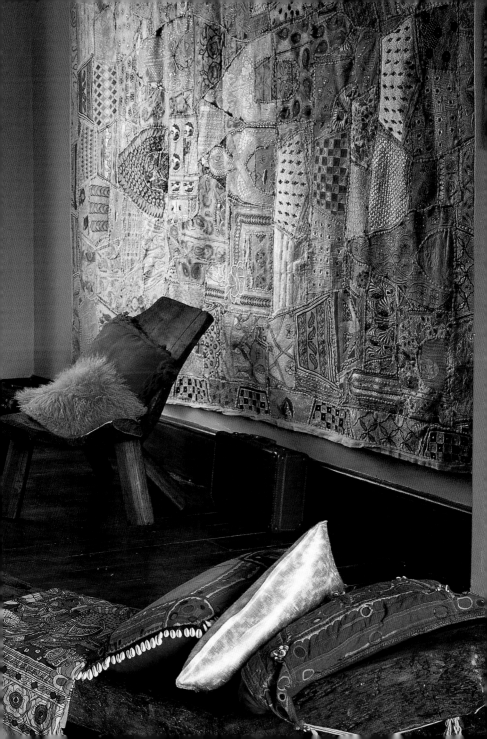

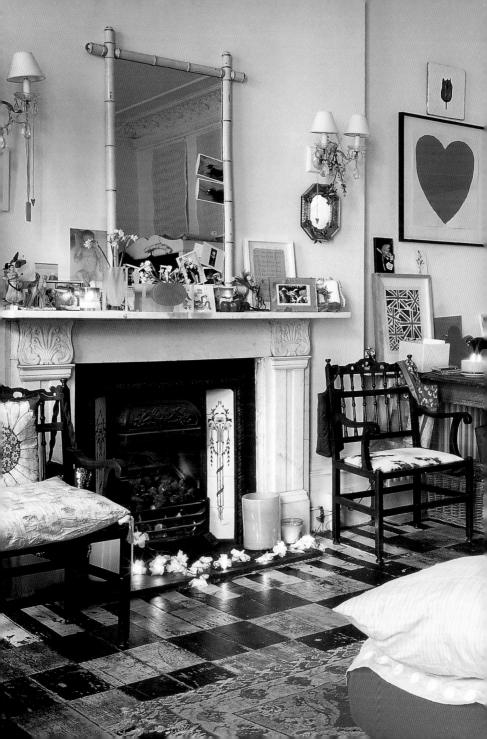

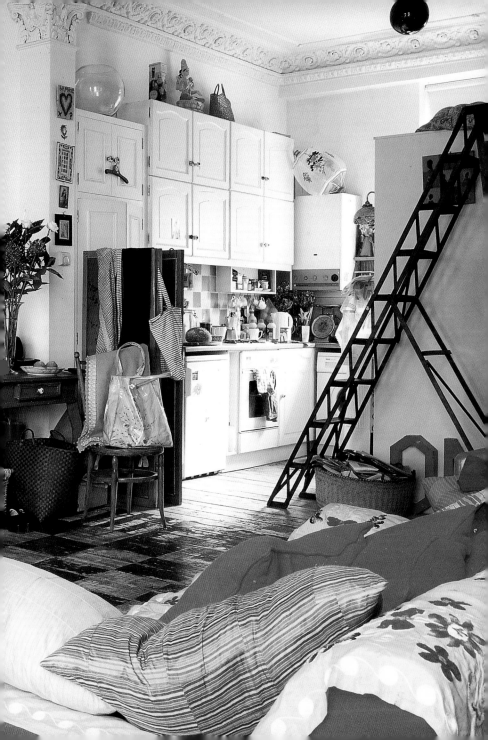

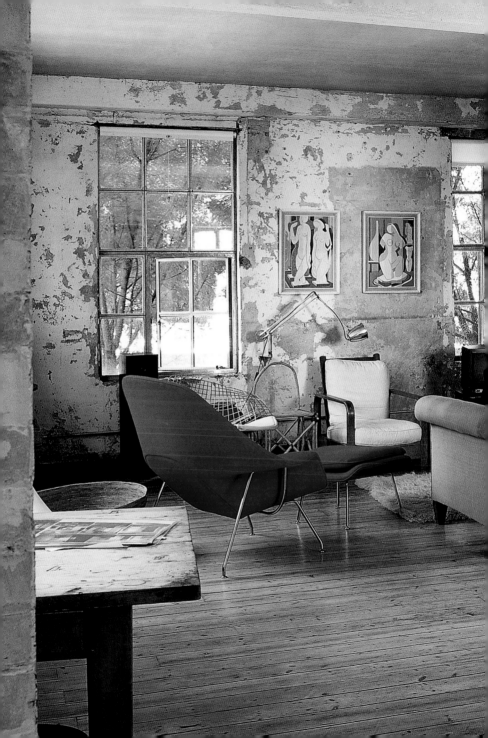

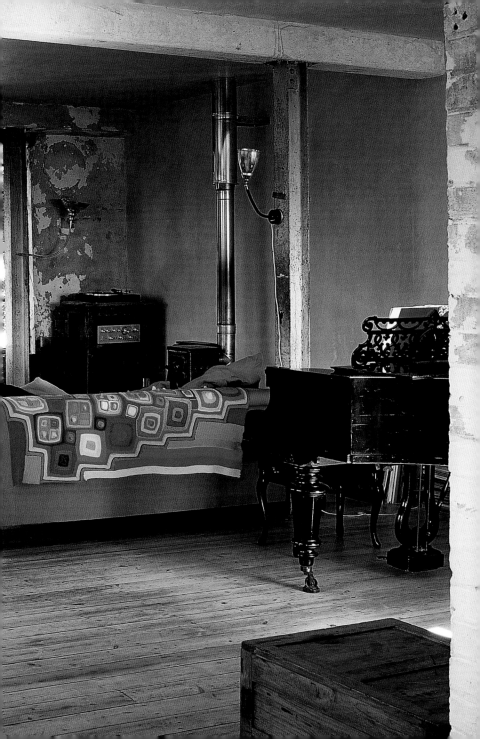

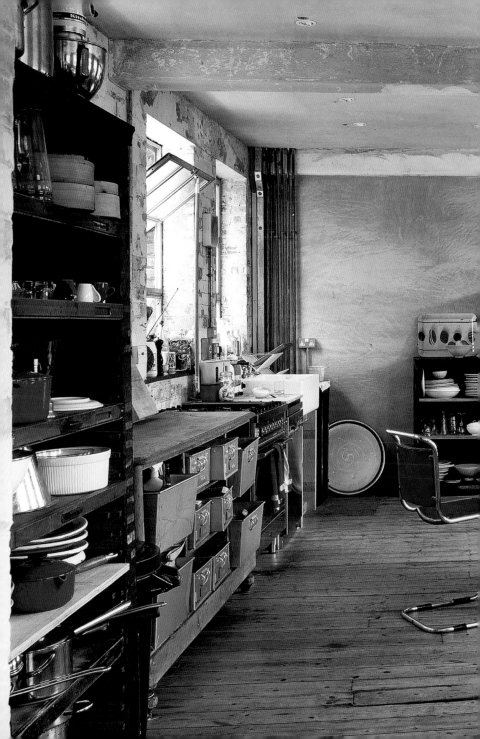

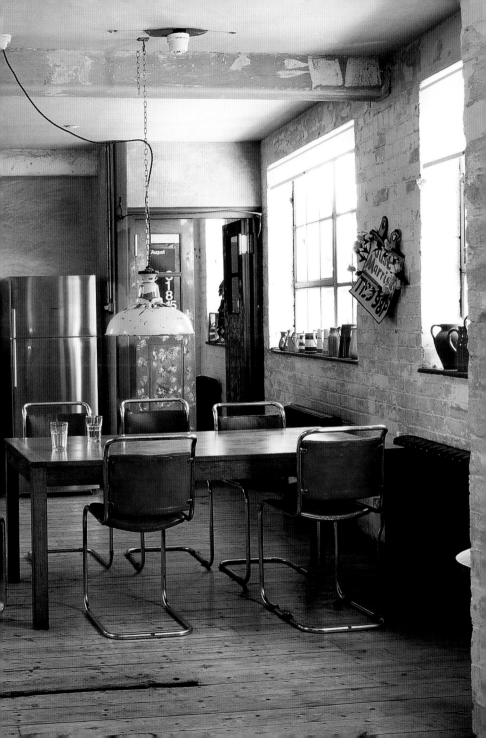

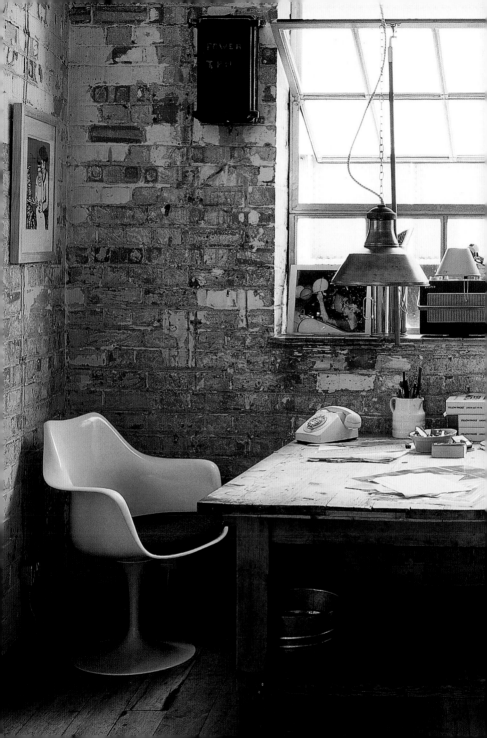

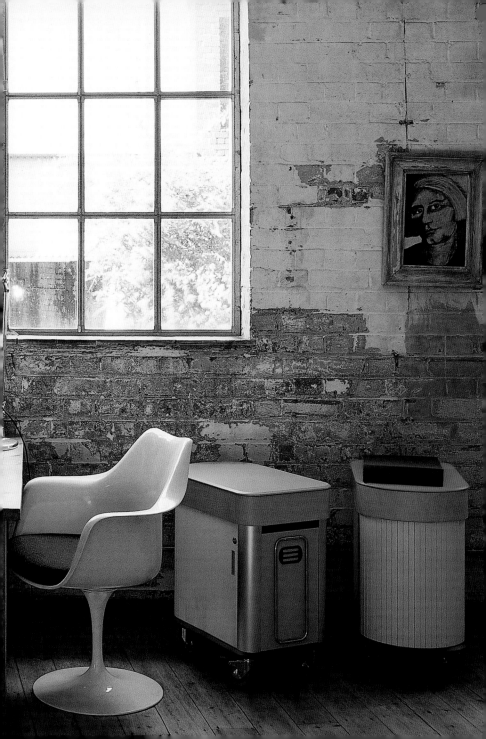

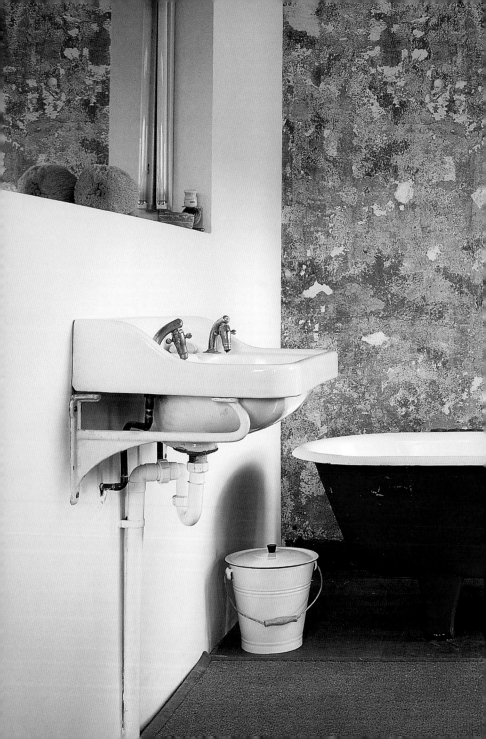

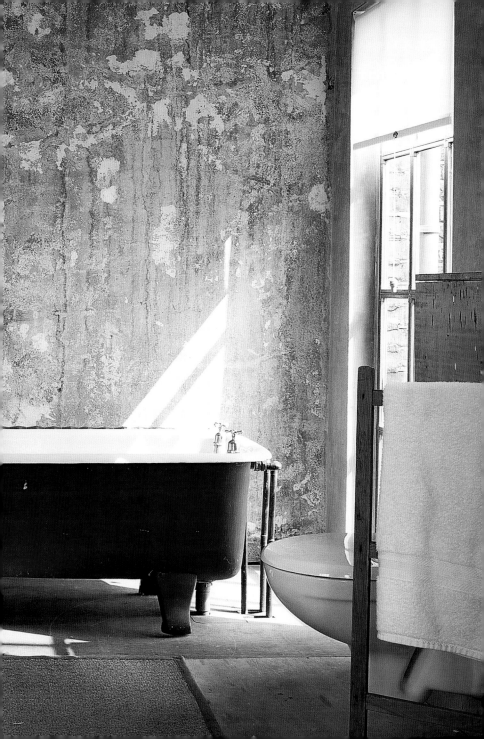

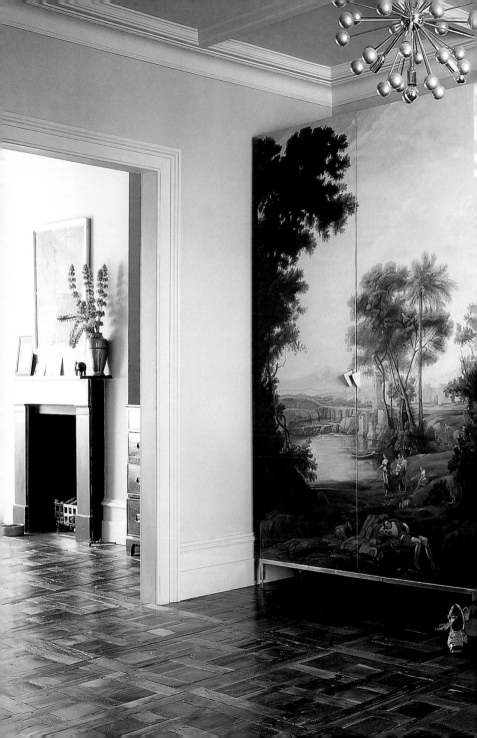

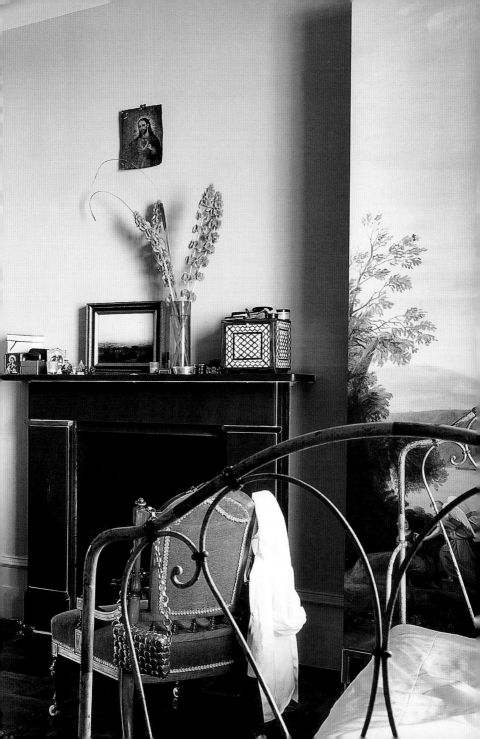

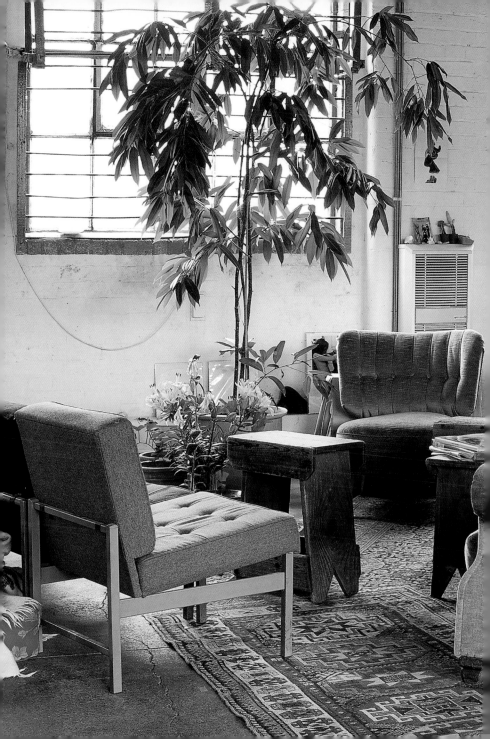

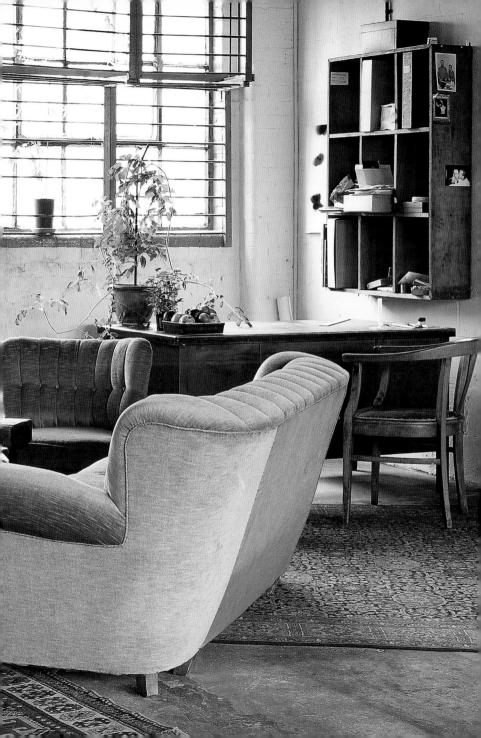

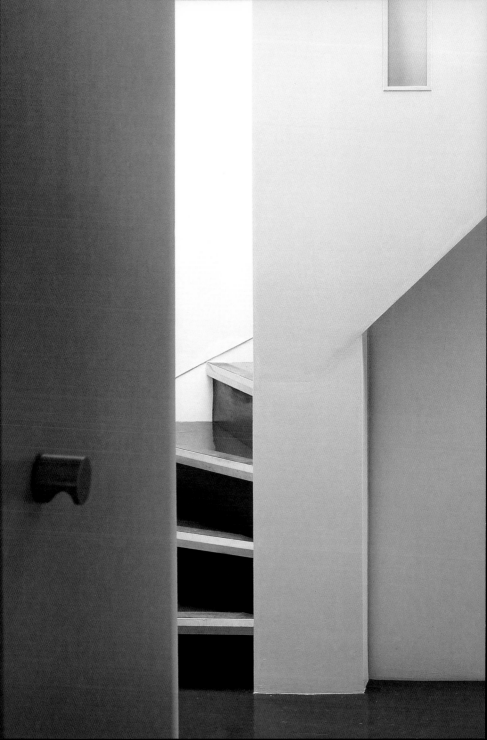

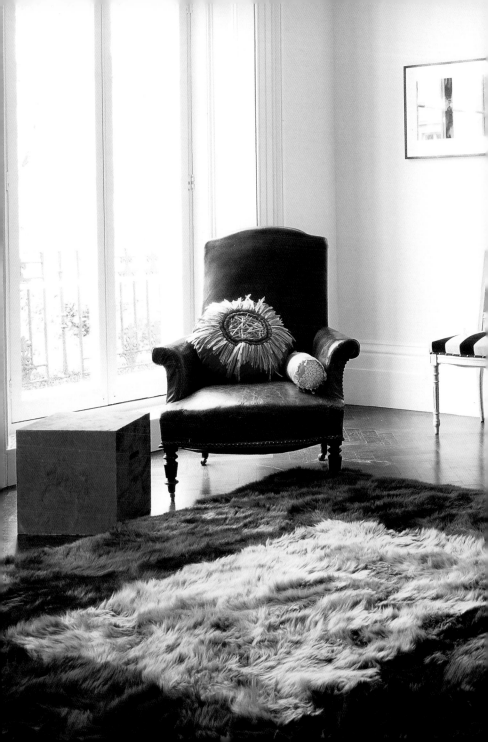

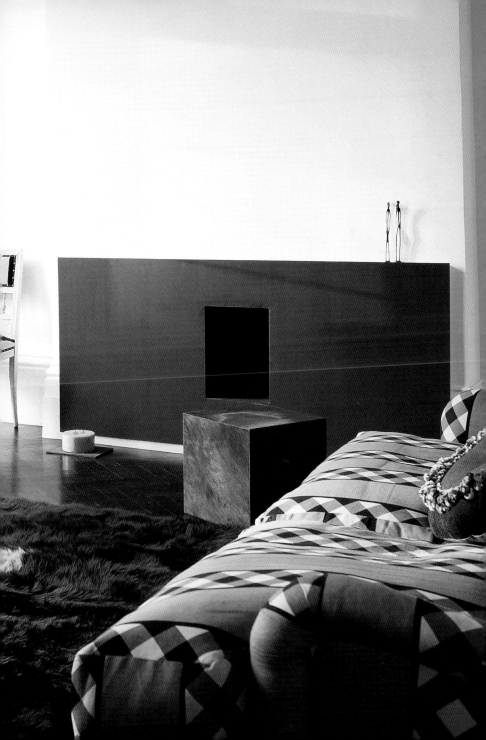

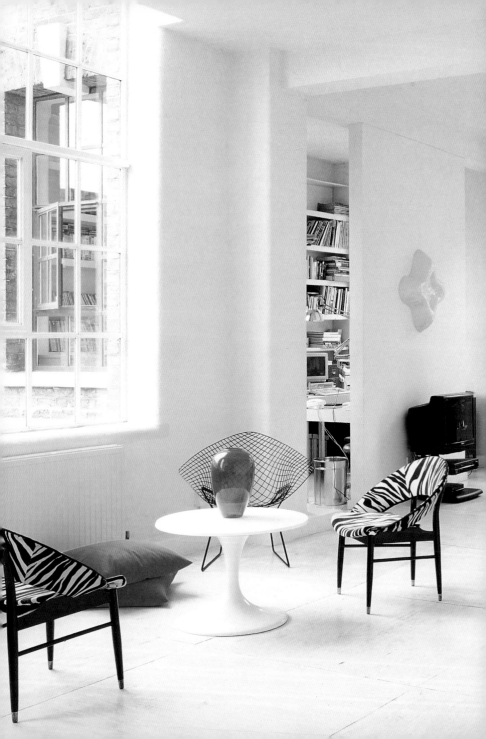

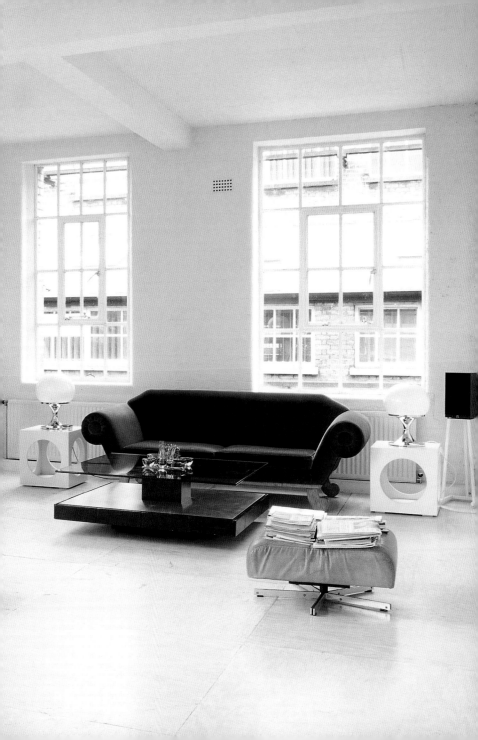

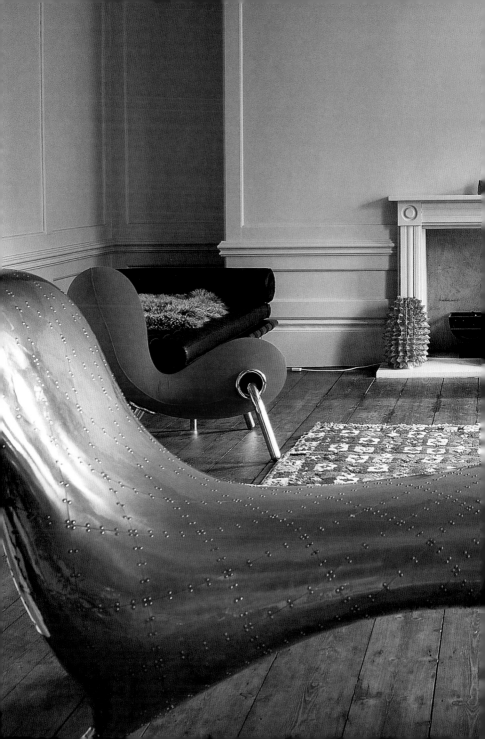

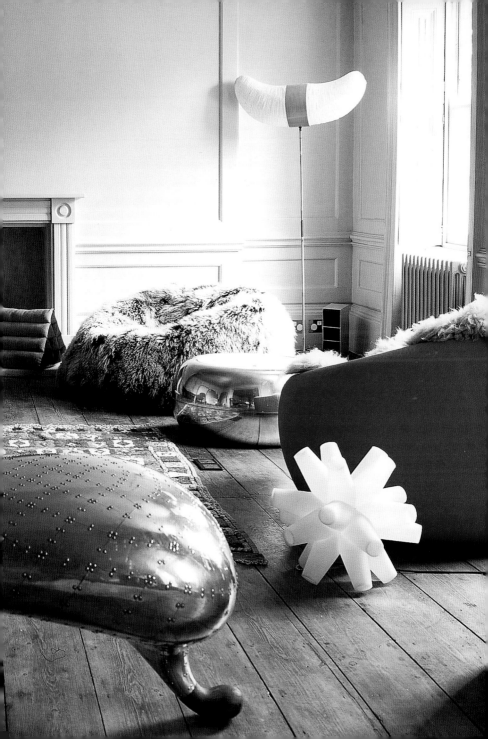

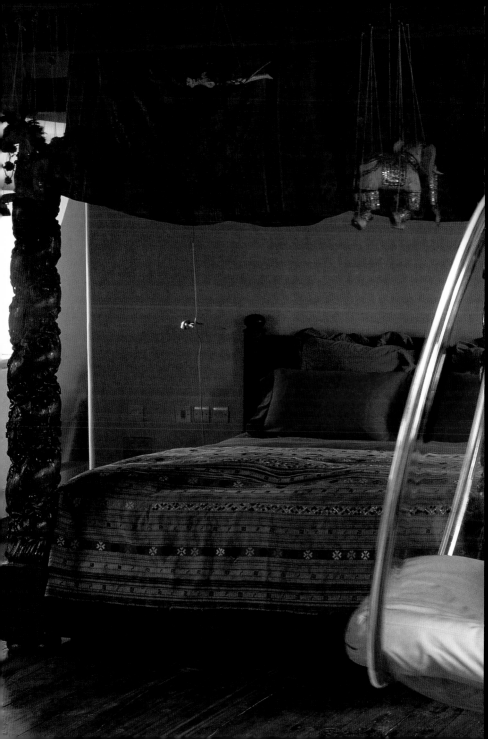

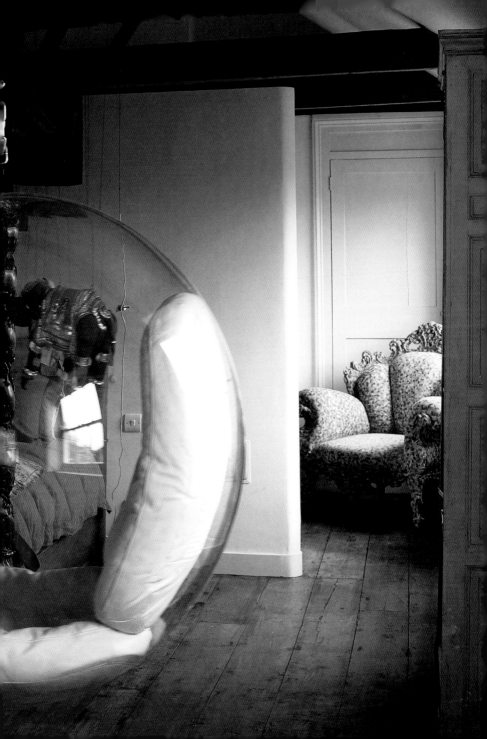

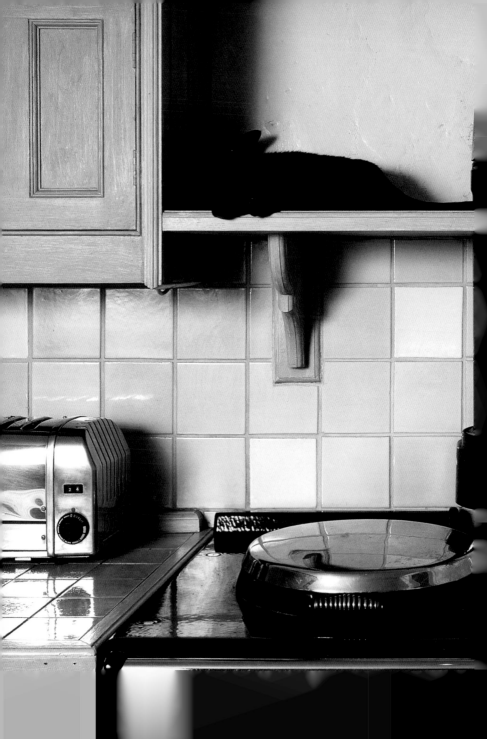

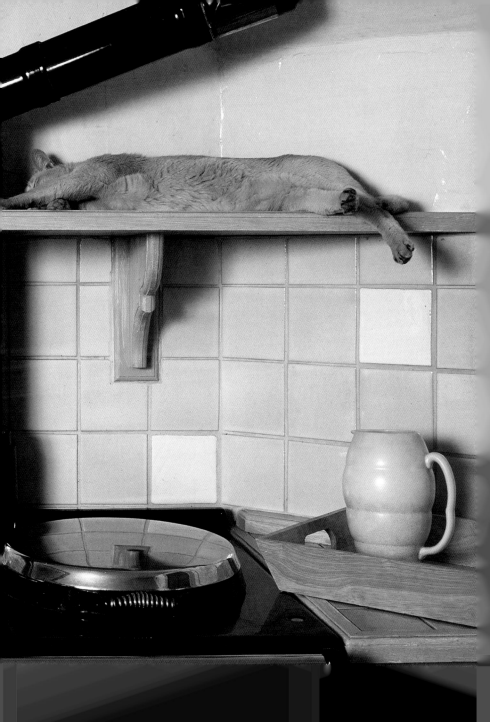

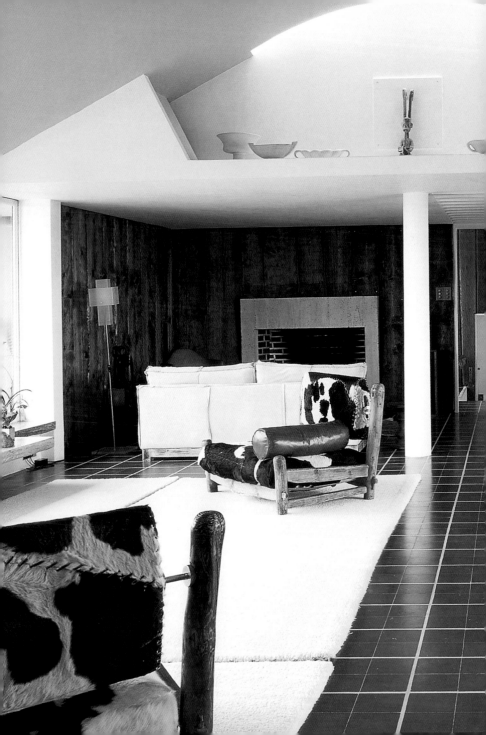

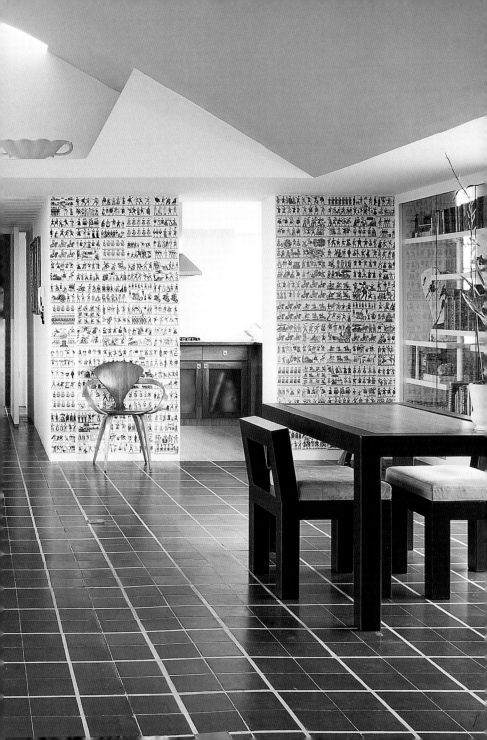

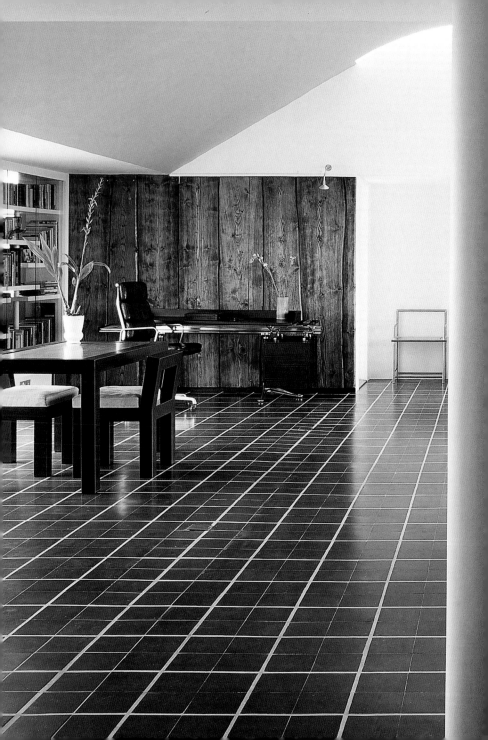

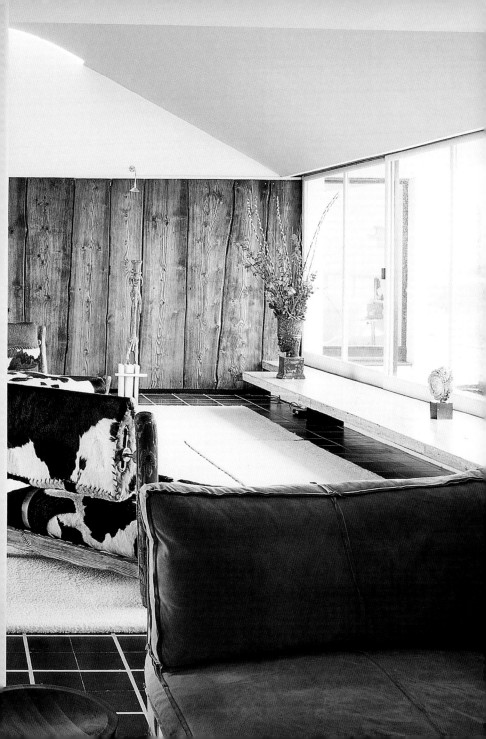

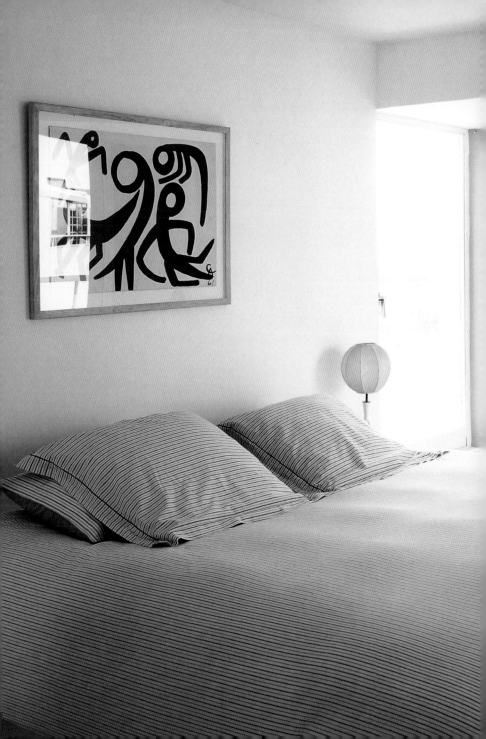

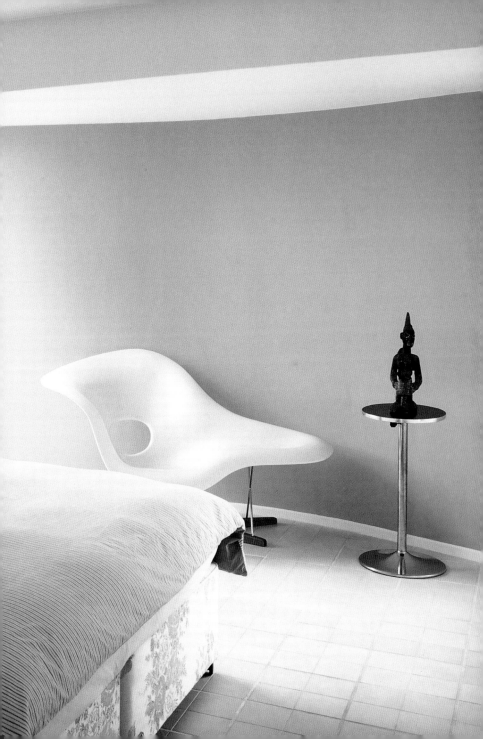

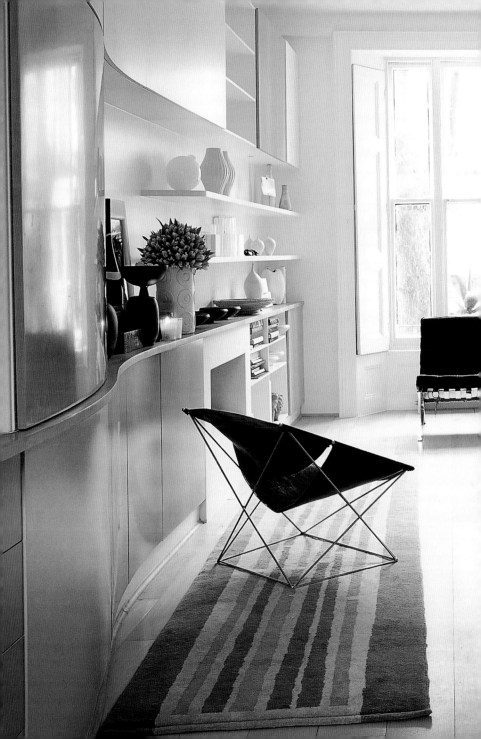

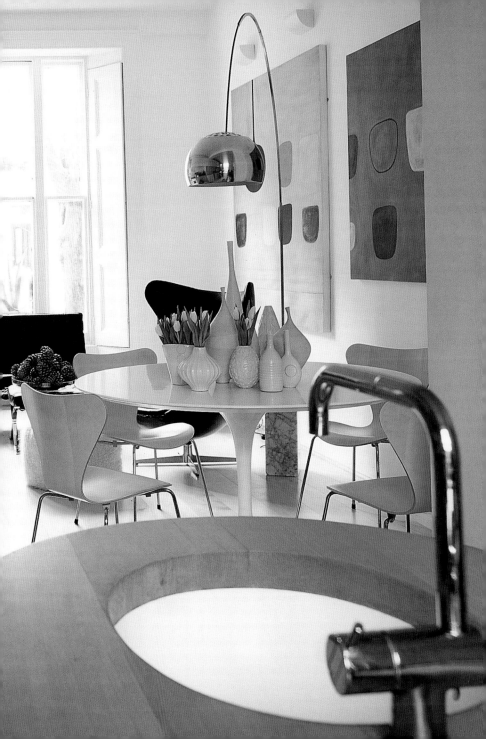

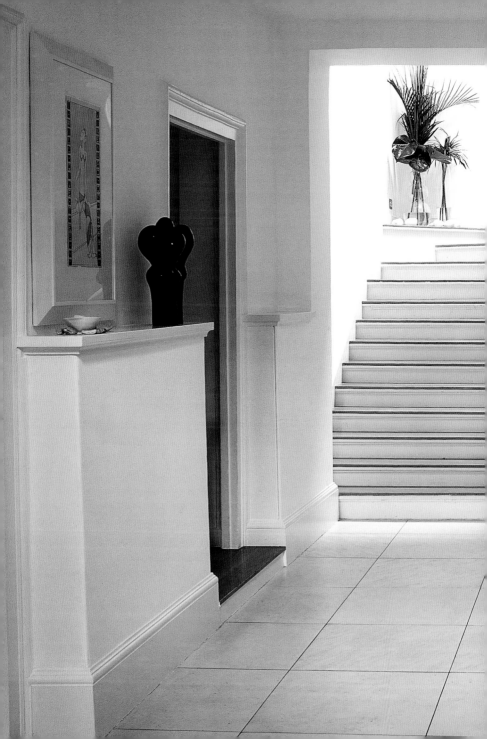

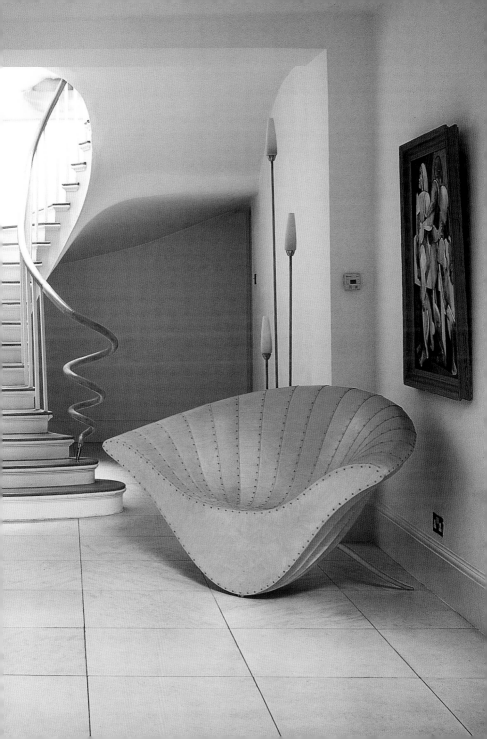

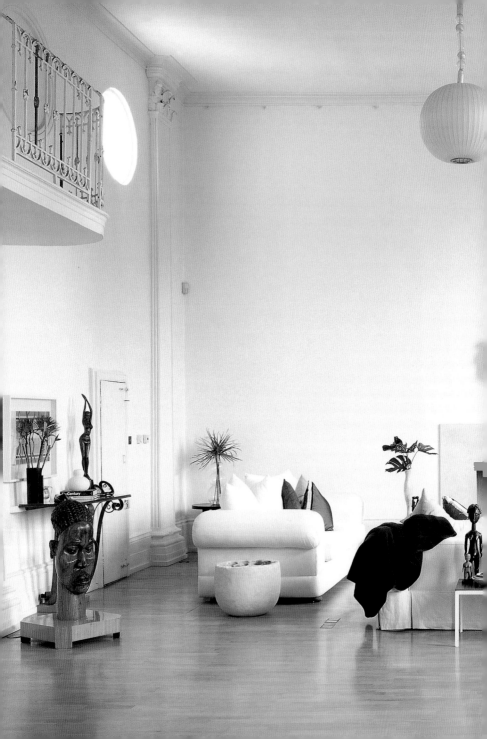

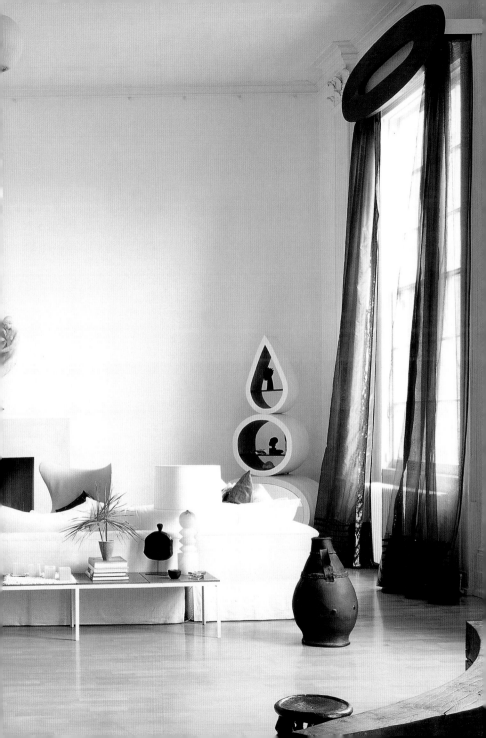

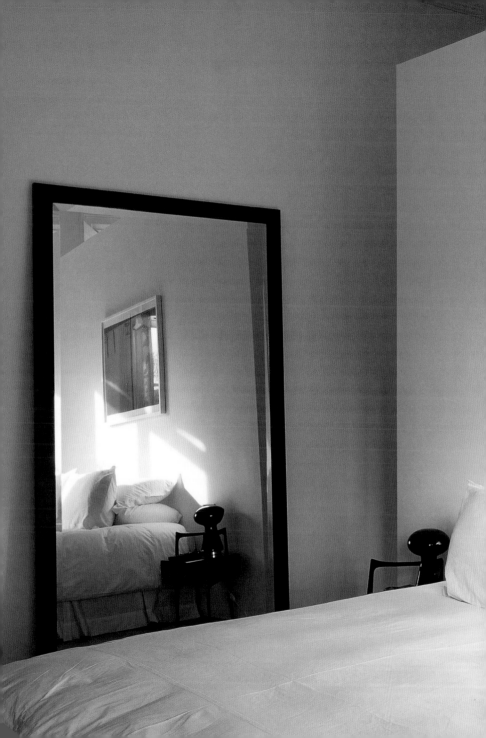

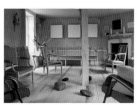

40/41 The dining room of Hassan Abdullah, Michel Lasserre + Stefan Karlson. *La salle à manger de Hassan Abdullah, Michel Lasserre + Stefan Karlson.* Das Esszimmer von Hassan Abdullah, Michel Lassere + Stefan Karlson.

42/43 The proprietors in their Victorian pub near Liverpool Street. *Les propriétaires dans leur pub victorien près de Liverpool Street.* Die Hausbesitzer in ihrem viktorianischen Pub nahe Liverpool Street.

44/45 The reception room of a North London Georgian town house. *La salle de réception d'une maison georgienne au nord de Londres.* Der Empfangsraum eines georgianischen »town house« im Norden Londons.

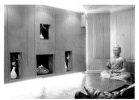

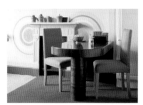

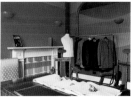

46/47 A work by Douglas Gordon in Carolyn Corben's Clapham flat. *Une œuvre de Douglas Gordon dans l'appartement de Carolyn Corben à Clapham.* Eine Arbeit von Douglas Gordon in Carolyn Corbens Wohnung in Clapham.

48/49 Murals by Kevin Allison in Ozwald Boateng's kitchen. *Les peintures murales de Kevin Allison dans la cuisine d'Ozwald Boateng.* Wandmalereien von Kevin Allison in Ozwald Boatengs Küche.

50/51 Inside the Wimpole Street couture house of fashion designer Ozwald Boateng. *Dans la maison de couture d'Ozwald Boateng sur Wimpole Street.* Im Modehaus von Designer Ozwald Boateng in der Wimpole Street.

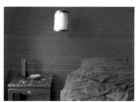

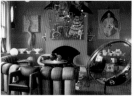

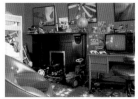

52/53 Boateng's bedroom on the fifth floor of his house. *Le quatrième étage abrite la chambre à coucher de Boateng.* Im vierten Stock befindet sich Boatengs Schlafzimmer.

54/55 The colourful "den" of Abdullah, Lasserre + Karlson. *«L'antre» coloré de Abdullah, Lasserre + Karlson.* Das farbenfrohe Herrenzimmer von Abdullah, Lasserre + Karlson.

56/57 The children's room in Solange Azagury-Partridge's flat. *Une chambre d'enfants dans l'appartement de Solange Azagury-Partridge.* Ein Kinderzimmer in Solange Azagury-Partridges Wohnung.

58/59 The kitchen island in the house of Nick Hastings + Denise Hurst. *L'îlot central de la cuisine de Nick Hastings + Denise Hurst.* Die Kücheninsel im Haus von Nick Hastings + Denise Hurst.

60/61 The children's bedroom in Nick Hastings + Denise Hurst's house. *La chambre d'enfants dans la maison de Nick Hastings + Denise Hurst.* Das Kinderzimmer im Haus von Nick Hastings + Denise Hurst.

62/63 Artists Michael Landy + Gillian Wearing's loft near Brick Lane. *Les artistes Michael Landy + Gillian Wearing vivent dans un loft près de Brick Lane.* Die Künstler Michael Landy + Gillian Wearing haben ein Loft nahe Brick Lane.

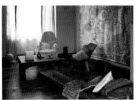

64/65 Michael Landy's "personalized crates" act as movable walls. *Les «caisses personalisées» de Michael Landing servent de murs amovibles.* Michael Landys »personalisierte Stapelboxen« dienen als bewegliche Wände.

66/67 Musician Talvin Singh's bedroom-cum-practice room. *La chambre à coucher/cabinet de travail du musicien Talvin Singh.* Das Schlaf- und Arbeitszimmer des Musikers Talvin Singh.

68/69 The living room of Singh's Victorian terraced house in East London. *Le salon dans la maison victorienne de Singh à l'est de Londres.* Das Wohnzimmer in Singhs viktorianischem Reihenhaus im Osten Londons.

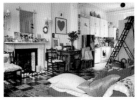

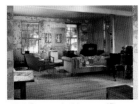

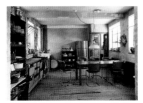

70/71 Sam Robinson's studio flat in Notting Hill. *Le studio de Sam Robinson à Notting Hill.* Das Studioapartment von Sam Robinson in Notting Hill.

72/73 The open-plan living room of Tom + Polly Lloyd's house in Hackney. *La grande salle de séjour dans la maison de Tom + Polly Lloyd à Hackney.* Der große Wohnbereich in Tom + Polly Lloyds Haus in Hackney.

74/75 The Lloyd's kitchen combines rustic simplicity with modern essentials. *La cuisine des Lloyd associe une simplicité rustique au confort moderne.* Die Küche der Lloyds verbindet rustikale Einfachheit mit Komfort.

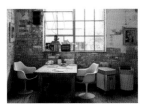

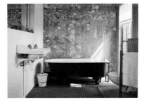

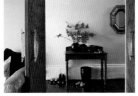

76/77 Tom + Polly Lloyd's house used to be a printing workshop. *La maison de Tom + Polly Lloyd était autrefois un atelier d'imprimerie.* Früher war das Haus von Tom + Polly Lloyd eine Druckerei.

78/79 The "new" bathroom in the Lloyd's Victorian house. *La nouvelle salle de bains dans la maison victorienne des Lloyd.* Neues Badezimmer im viktorianischen Haus der Lloyds.

80/81 View into the hallway of Judy Kleinman's Notting Hill house. *Le couloir de la maison de Judy Kleinman à Notting Hill.* Blick in den Flur von Judy Kleinmans Haus in Notting Hill.

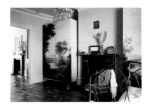

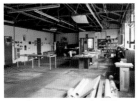

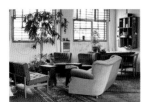

82/83 "Sputnik"-light and elegant bed in Kleinman's dressing room. *Une lampe «sputnik» et un lit élégant dans le dressing de Kleinman.* »Sputnik«-Lampe und elegantes Bett in Kleinmans Ankleidezimmer.

84/85 The studio of photographer Wolfgang Tillmans in Clerkenwell. *L'atelier du photographe Wolfgang Tillmans à Clerkenwell.* Das Studio des Fotografen Wolfgang Tillmans in Clerkenwell.

86/87 A blue three-piece-suite from the 60s in Tillmans' living room. *Le salon en velours bleu des années 1960 de Tillmans.* Dreiteilige blaue Veloursitzgruppe aus den 60ern in Tillmans Wohnzimmer.

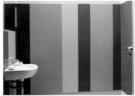

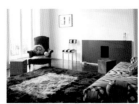

88/89 Shower in the West London house of Nick Hastings + Denise Hurst. *La douche dans la maison de Nick Hastings + Denise Hurst à l'ouest de Londres.* Dusche im Haus von Nick Hastings + Denise Hurst im Westen Londons.

90/91 View of the remodeled staircase in the Hastings' house. *Vue de la cage d'escalier rajeunie de la maison des Hastings.* Blick in das renovierte Treppenhaus im Haus der Hastings.

92/93 The living room of the Hastings' home is dominated by a sheepskin rug. *Un grand tapis en poils de mouton règne dans le salon des Hastings.* Das Wohnzimmer der Hastings wird von einem Schaffellteppich dominiert.

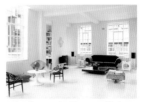

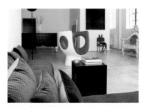

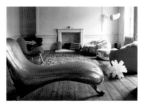

94/95 The open-plan living room of Paul Brewster + Shaun Clarkson in Shoreditch. *Le séjour ouvert de Paul Brewster + Shaun Clarkson à Shoreditch.* Das großzügige Wohnzimmer von Paul Brewster + Shaun Clarkson.

96/97 David Gill's living room in an old factory building in Vauxhall. *Le séjour de David Gill dans un vieux bâtiment industriel de Vauxhall.* David Gills Wohnraum in einem alten Fabrikgebäude in Vauxhall.

98/99 Stephen Palmer + Jacqueline Lucas' drawing room in their Georgian house. *Le salon de Stephen Palmer + Jacqueline Lucas dans leur maison fin 18e.* Salon in Stephen Palmers + Jacqueline Lucas' georgianischem Haus.

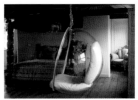

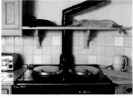

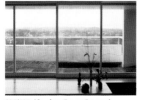

100/101 Eero Aarnio's "Bubble Chair" in Palmer + Lucas's bedroom. *Un fauteuil «Bubble» d'Eero Aarnio dans la chambre de Palmer + Lucas.* Eero Aarnios »Bubble Chair« in Palmers + Lucas' Schlafzimmer.

102/103 The kitchen of a North London Georgian town house. *La cuisine d'une maison georgienne au nord de Londres.* Die Küche eines georgianischen »town house« im Norden Londons.

104/105 View from the penthouse of Baholyodhin + Yardeni in Highpoint Two. *Vue du penthouse de Baholyodhin + Yardeni à Highpoint Two.* Blick aus dem Penthouse von Baholyodhin + Yardeni in Highpoint Two.

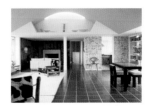

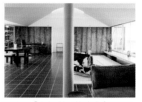

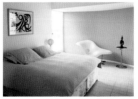

106/107 Inside the penthouse of Ou Baholyodhin + Erez Yardeni. *Dans le penthouse d'Ou Baholyodhin + Erez Yardeni.* Im Penthouse von Ou Baholyodhin + Erez Yardeni.

108/109 Baholyodhin + Yardeni's flat centres around a huge living room. *Une immense salle de séjour domine l'appartement de Baholyodhin + Yardeni.* Mittelpunkt der Wohnung von Baholyodhin + Yardeni ist der Wohnraum.

110/111 View of the bedroom in Baholyodhin + Yardeni's flat. *La chambre de l'appartement de Baholyodhin + Yardeni.* Blick in das Schlafzimmer von Baholyodhins + Yardenis Wohnung.

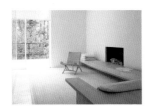 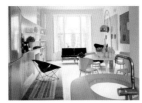 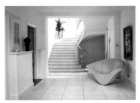

112/113 Living room of architect John Pawson and his wife Catherine. *La salle de séjour de l'architecte John Pawson et de son épouse Catherine.* Wohnzimmer des Architekten John Pawson und seiner Frau Catherine.

114/115 Classic 20th-century design in Nikki Tibbles' apartment. *Des classiques du 20e siècle meublent l'appartement de Nikki Tibbles.* Designklassiker des 20. Jahrhunderts in der Wohnung von Nikki Tibbles.

116/117 The elegant hallway of the Hampstead house of Nick + Maxine Leslau. *L'élégant couloir de la maison de Nick + Maxine Leslau à Hampstead.* Der elegante Flur in dem Haus von Nick + Maxine Leslau in Hampstead.

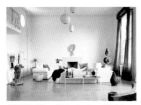 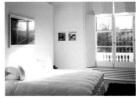

118/119 Nick + Maxine Leslau call their huge living room the "ballroom". *Nick + Maxine Leslau appellent leur séjour immense la «salle de bal».* Nick + Maxine Leslau nennen ihr riesiges Wohnzimmer den »Ballsaal«.

120/121 A bedroom in Oliver + Charlie Peyton's flat near Hyde Park. *Une chambre à coucher de l'appartement d'Oliver + Charlie Peyton près de Hyde Park.* Schlafzimmer in Oliver + Charlie Peytons Apartment.

122/123 Another bedroom in Oliver + Charlie Peyton's flat. *Une autre chambre à coucher de l'appartement d'Oliver + Charlie Peyton.* Ein weiteres Schlafzimmer im Apartment von Oliver + Charlie Peyton.

"The city blew the windows of my brain wide open. But being in a place so bright, fast and brilliant made you vertiginous with possibility…"

Hanif Kureishi, *The Buddha of Suburbia*, 1990

«La ville ouvrait toutes grandes les fenêtres de mon cerveau. Mais vivre dans un endroit si éclatant, vif et brillant offre des possibilités à donner le vertige…»

Hanif Kureishi, *Le Bouddha de banlieue*, 1990

»Das Leben in der City machte die Fenster in meinem Kopf weit auf. Wenn ich an die Möglichkeiten dachte, die sich mir an einem so bunten, schnellen und farbigen Ort eröffneten, wurde mir ganz schwindlig…«

Hanif Kureishi, *Der Buddha aus der Vorstadt*, 1990

DETAILS

Détails Details

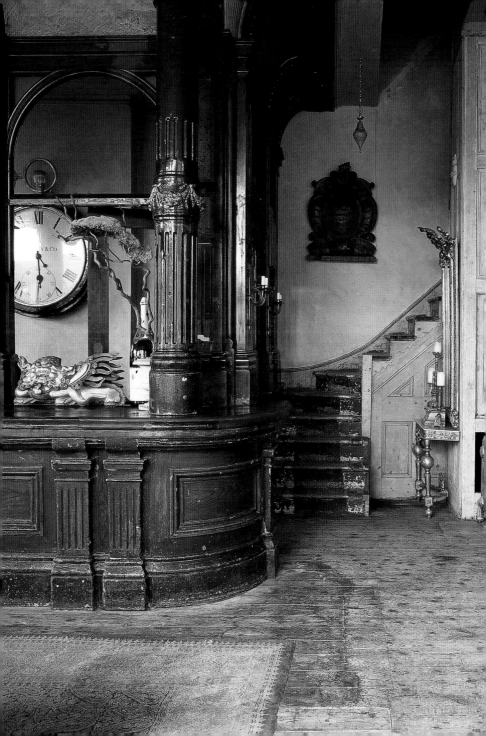

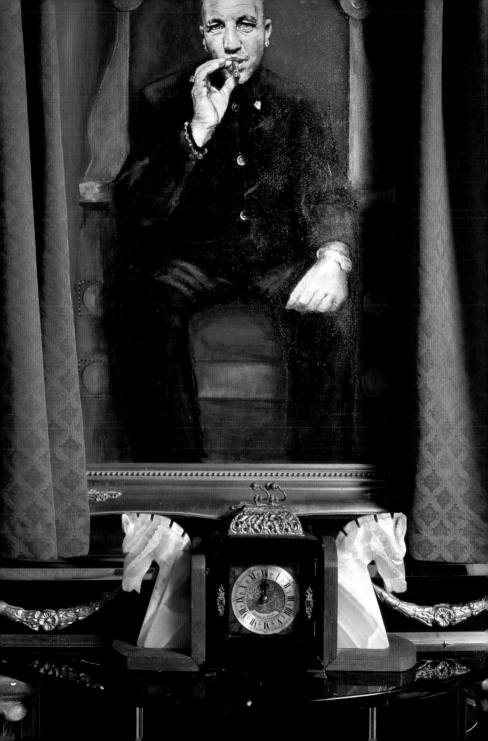

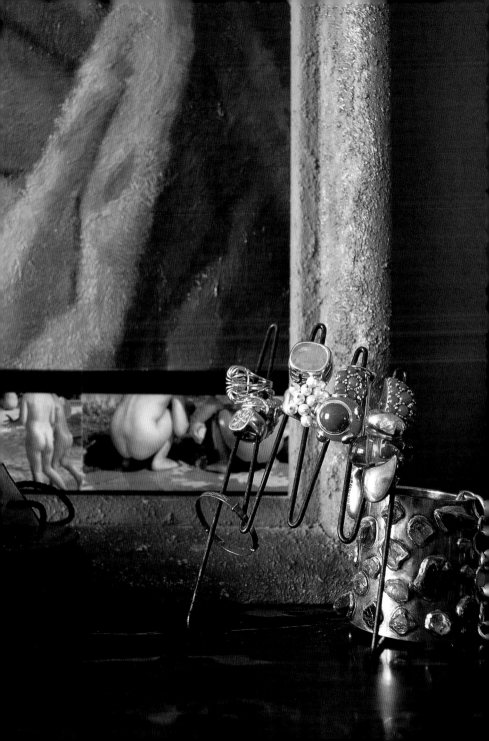

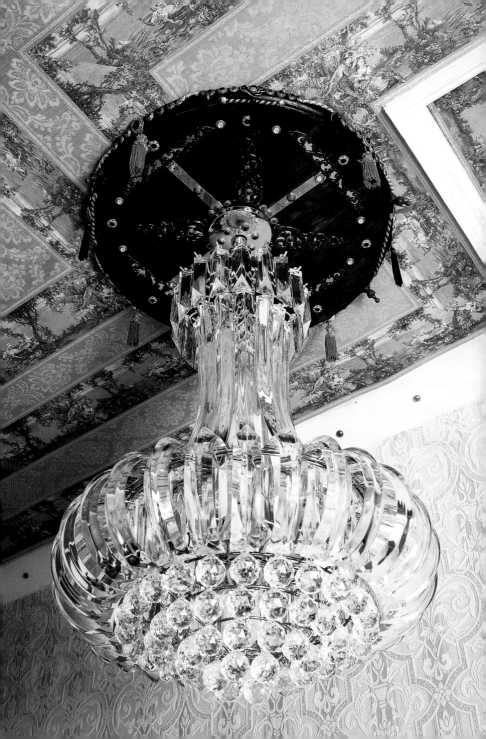

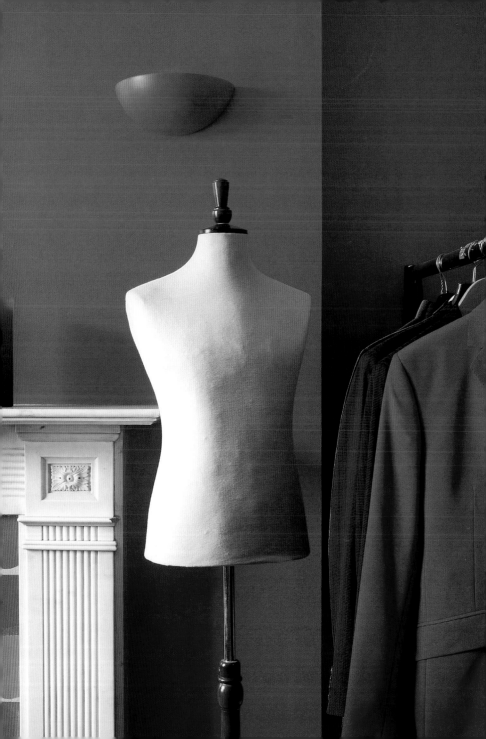

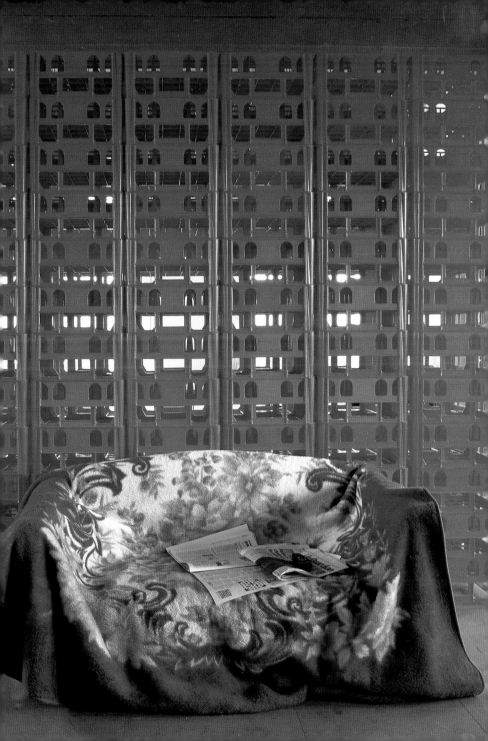

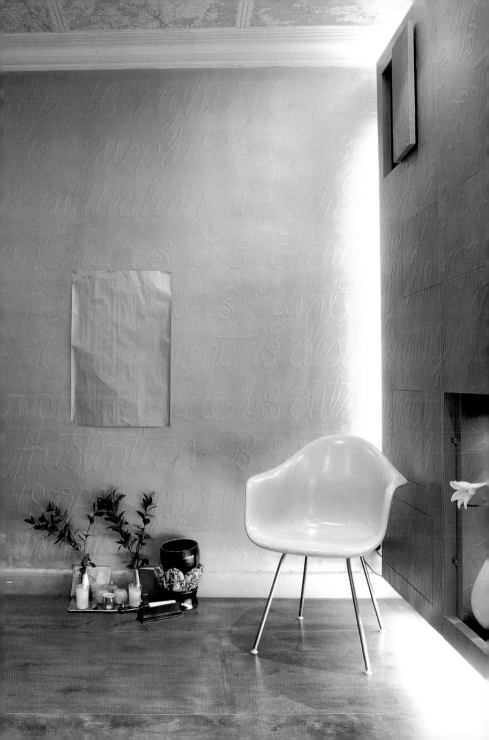

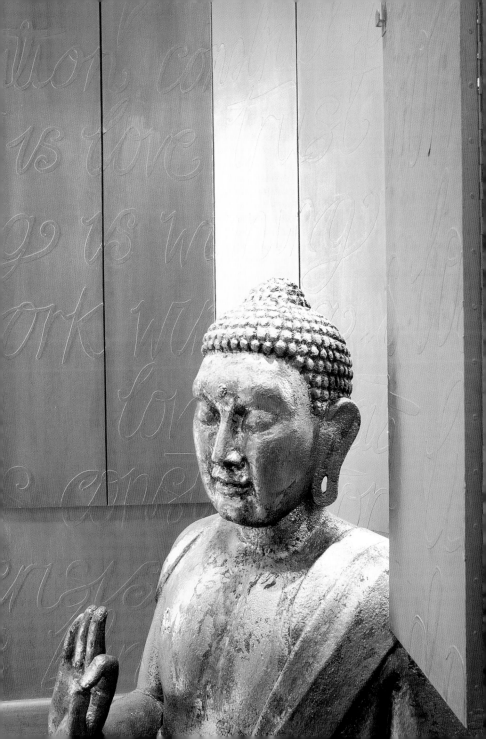

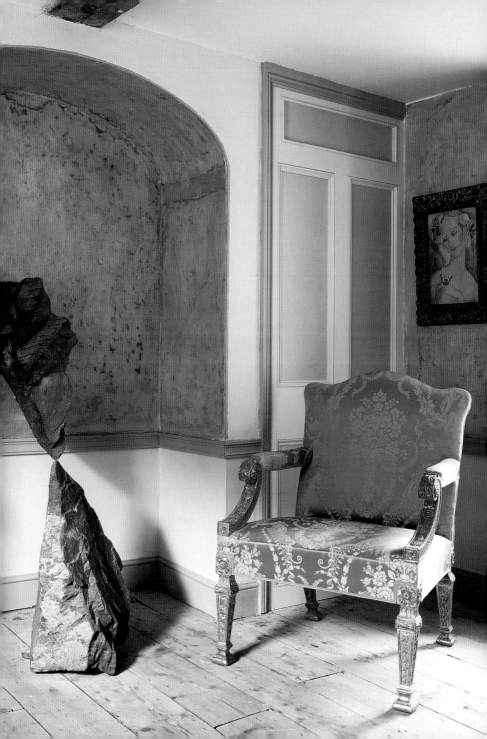

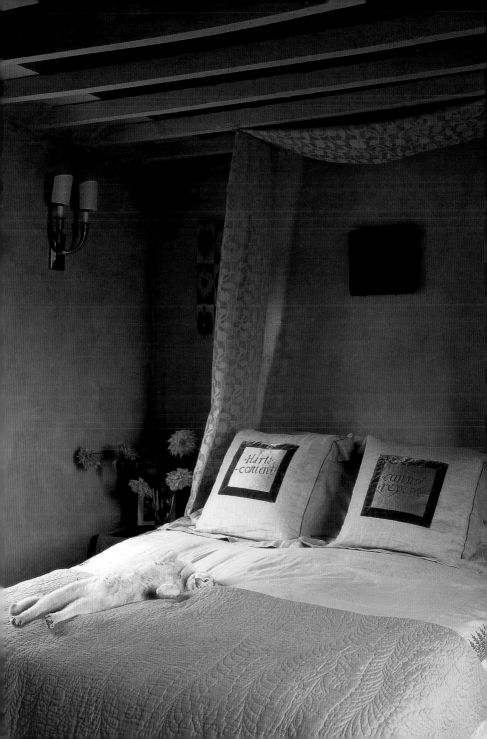

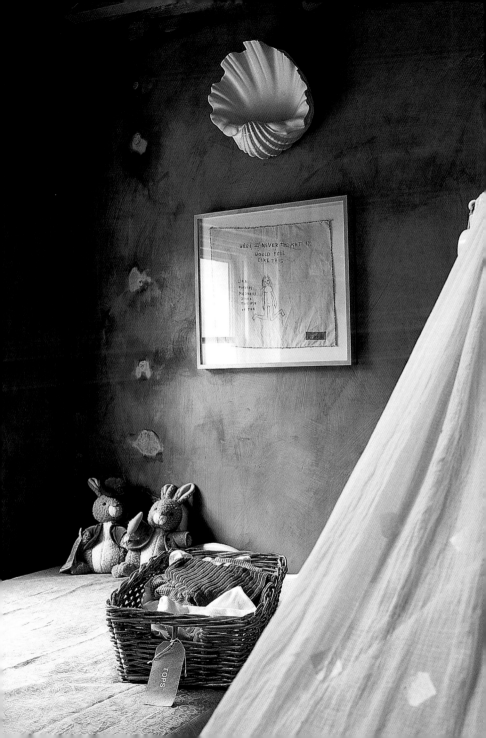

WELL I NEVER THOUGHT IT
WOULD FEEL
LIKE THIS

TOPS

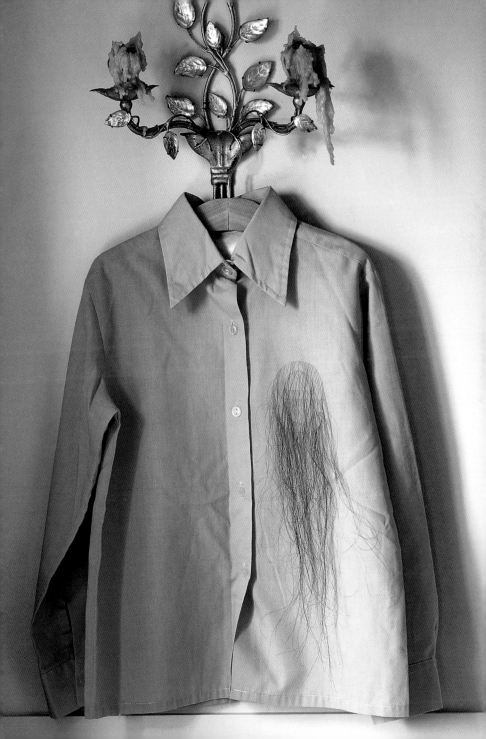

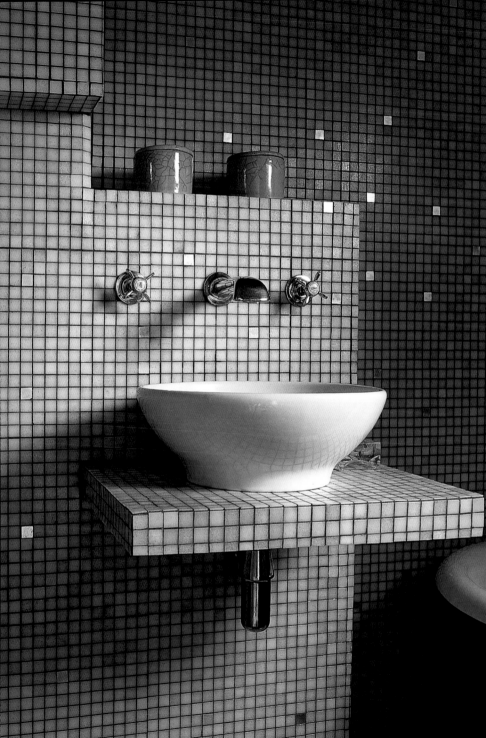

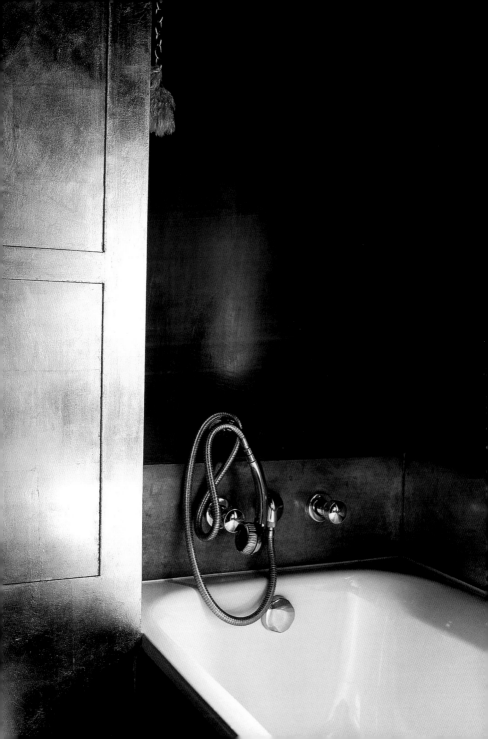

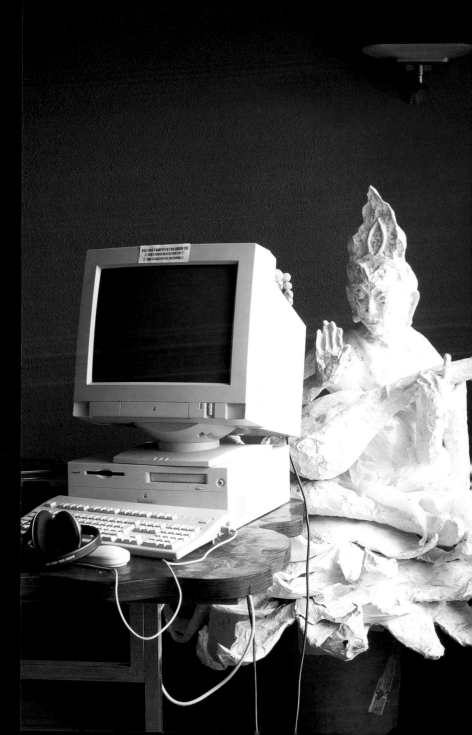

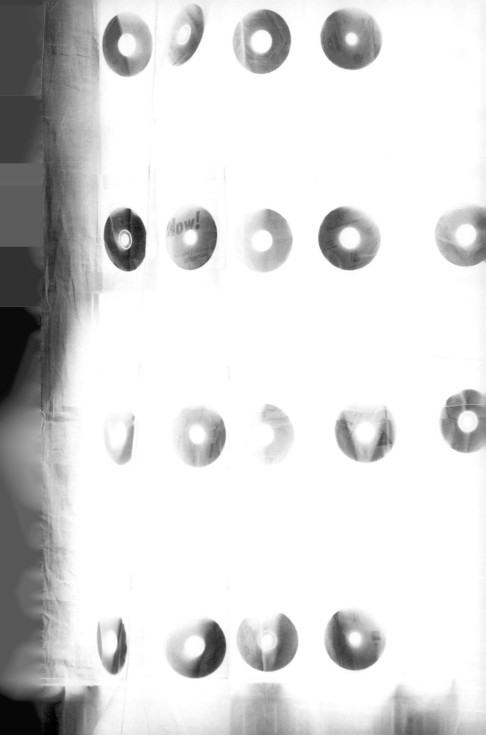

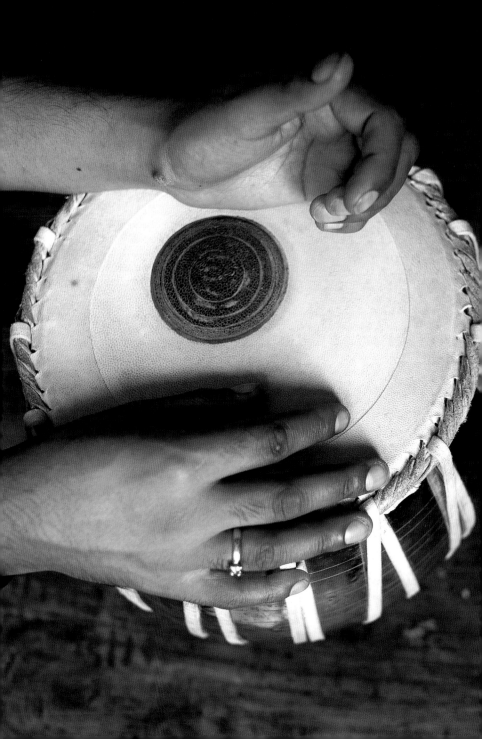

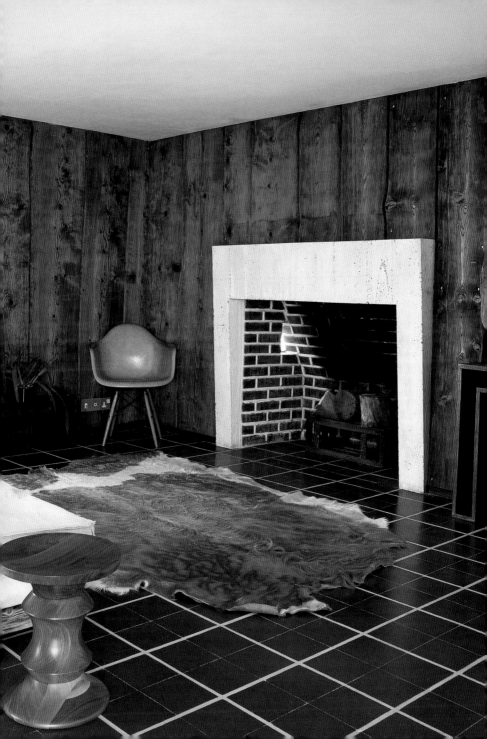

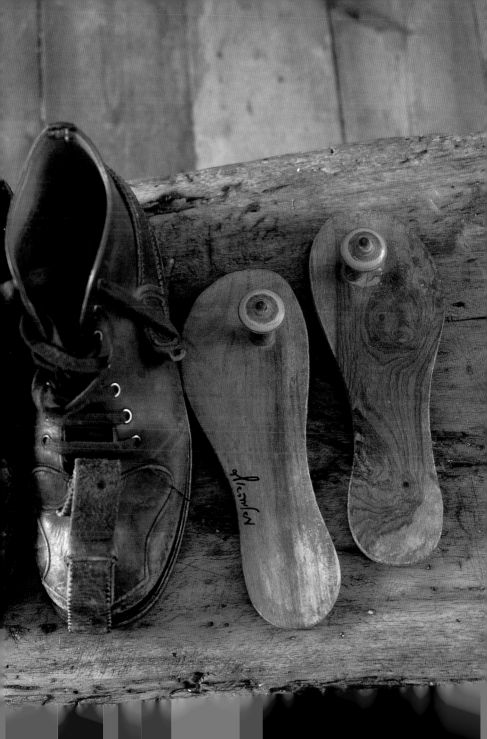

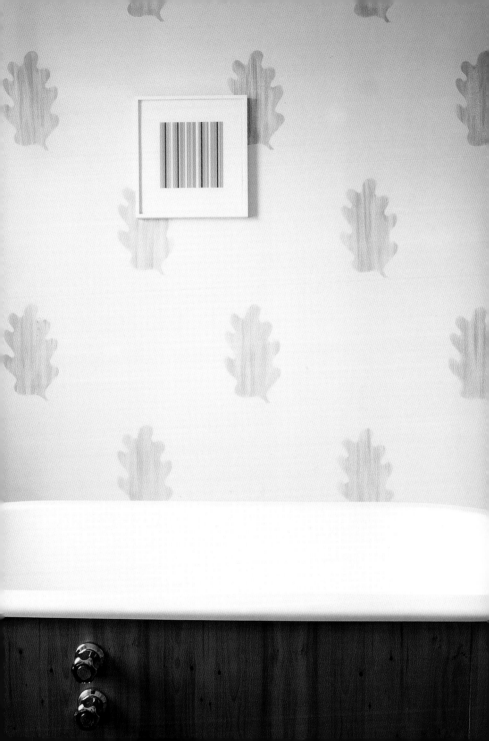

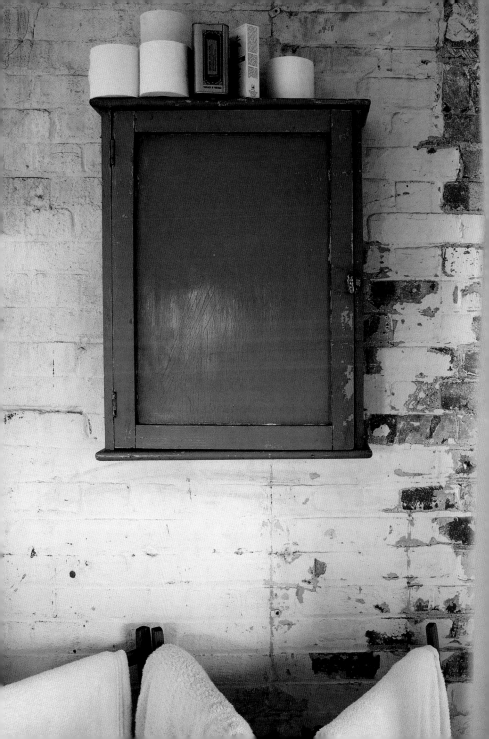

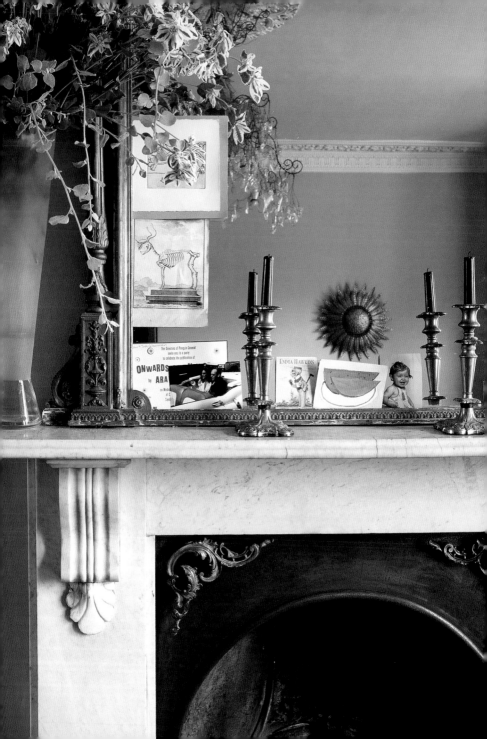

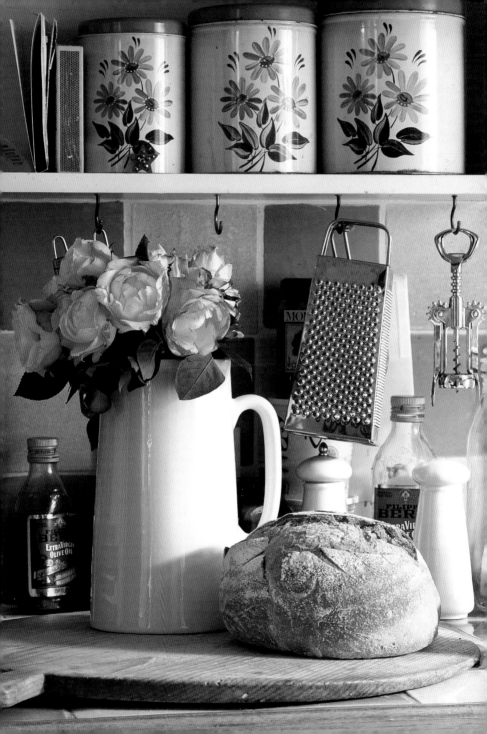

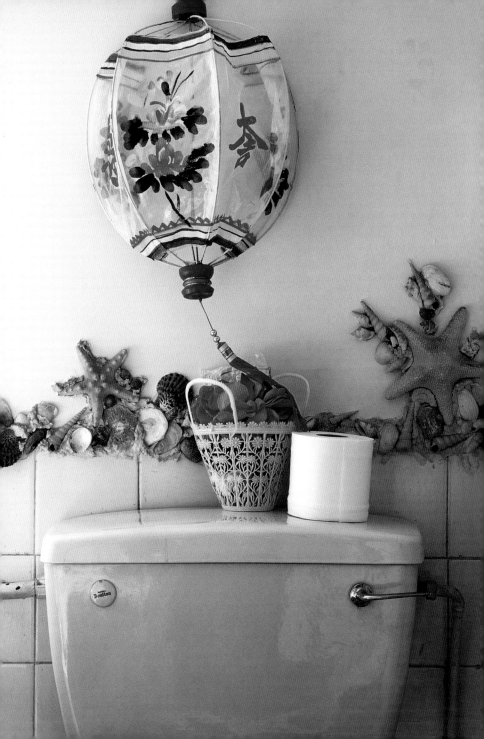

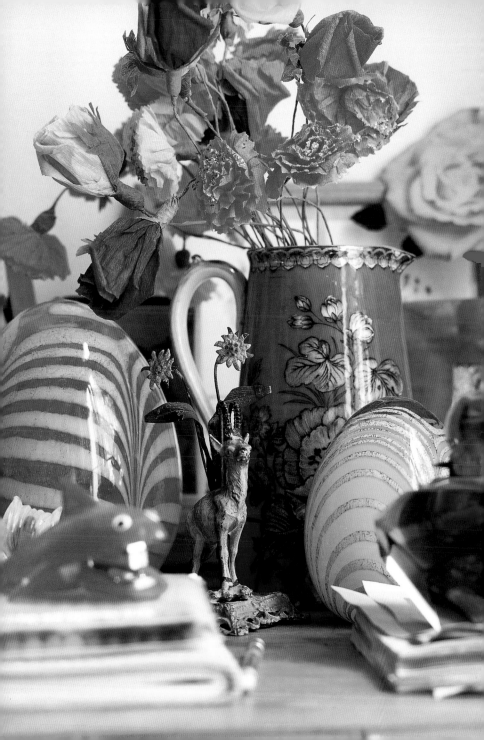

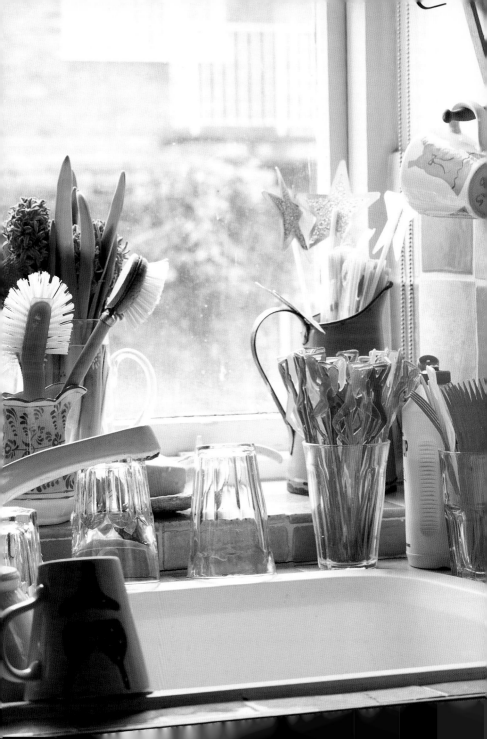

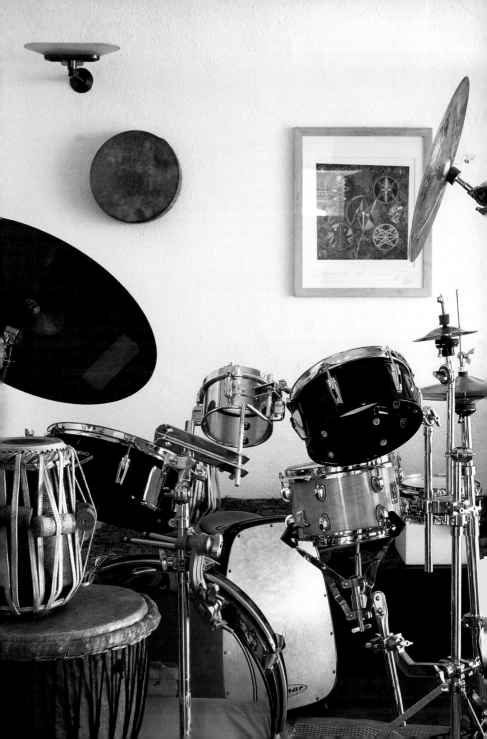

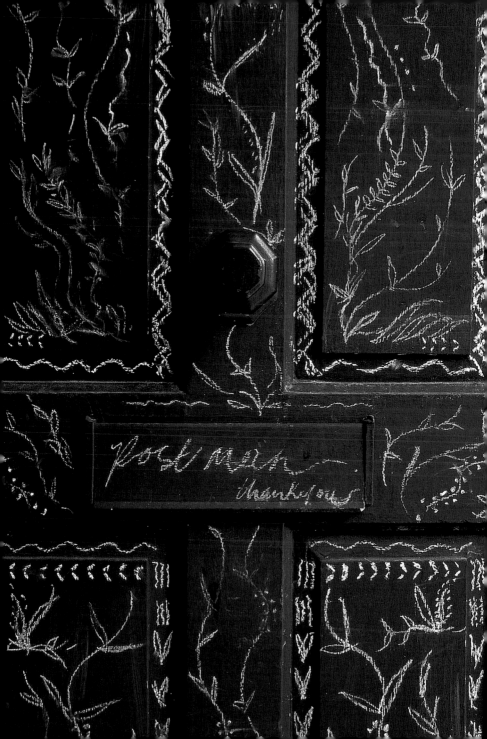

Avedon began his career at *Harper's Bazaar*. A Whitney Museum retrospective chronicles the life of his unparalleled artist. On these pages he comes famous again. By Amy Fine Collins Produced by Wendy Goodman

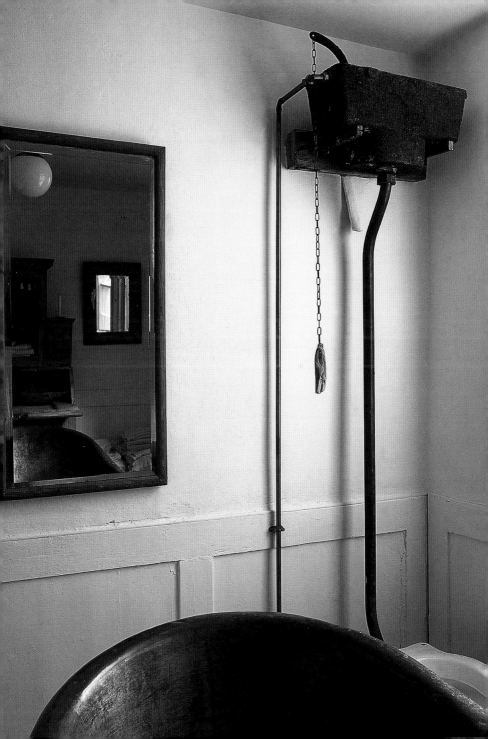

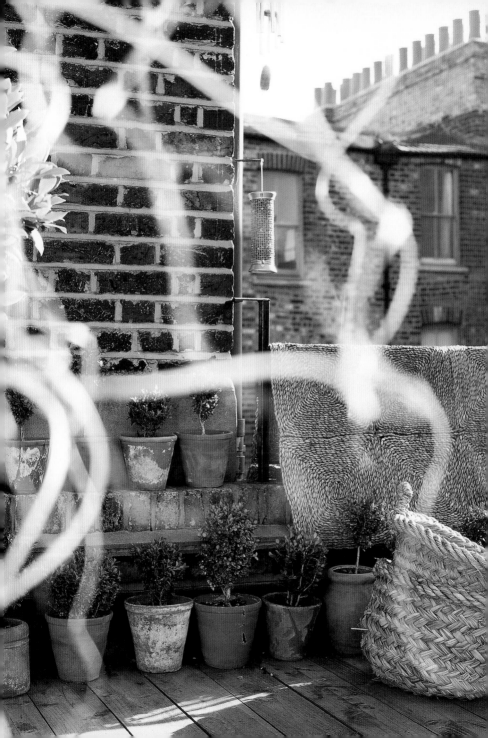

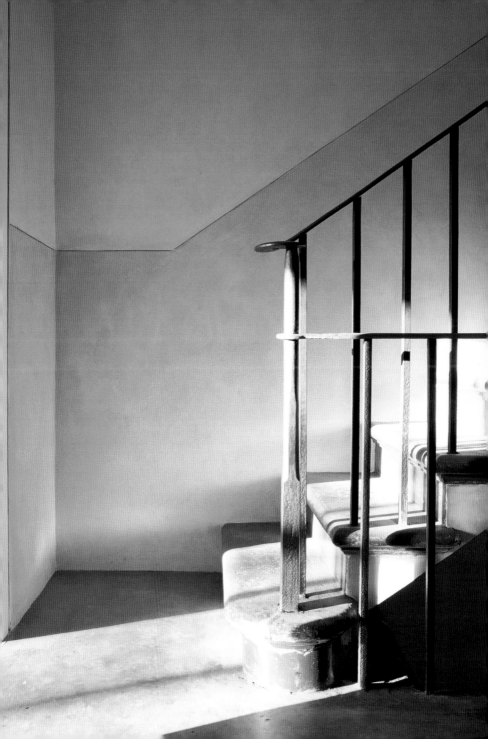

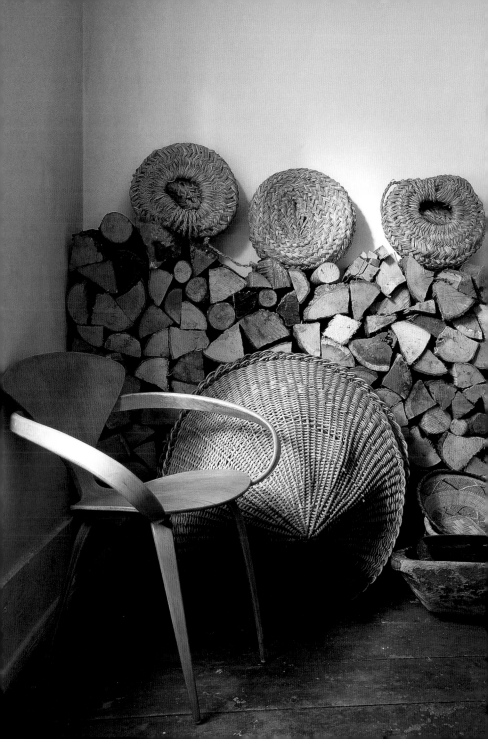

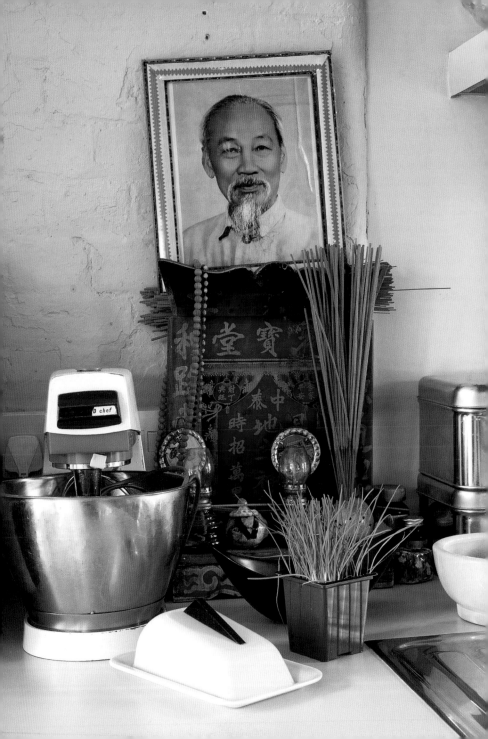

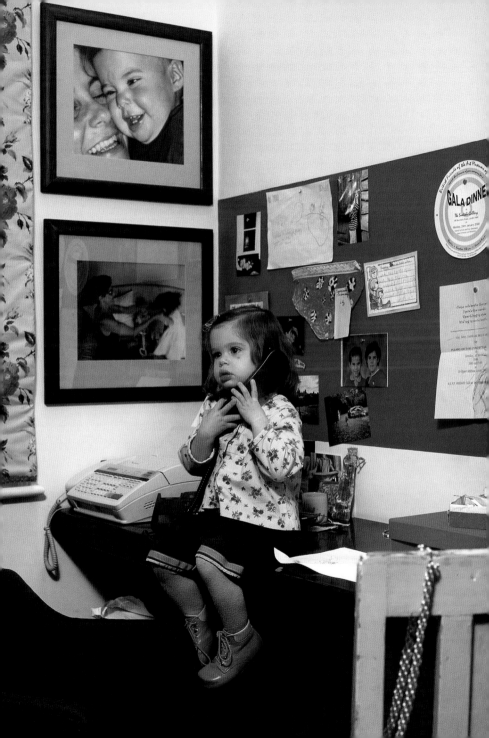

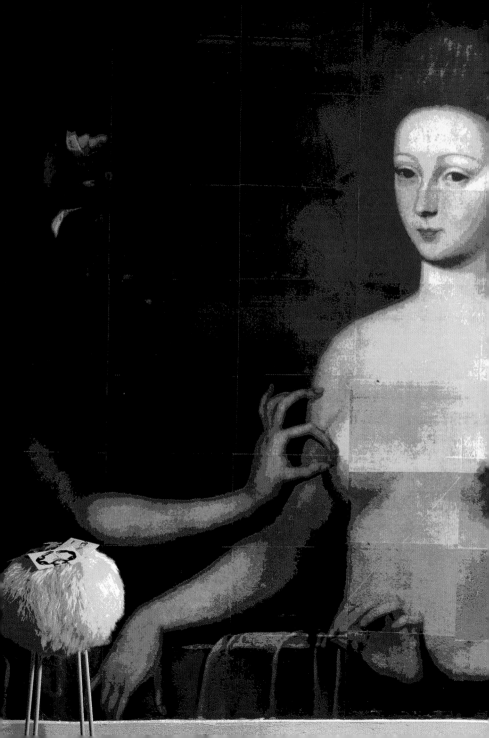

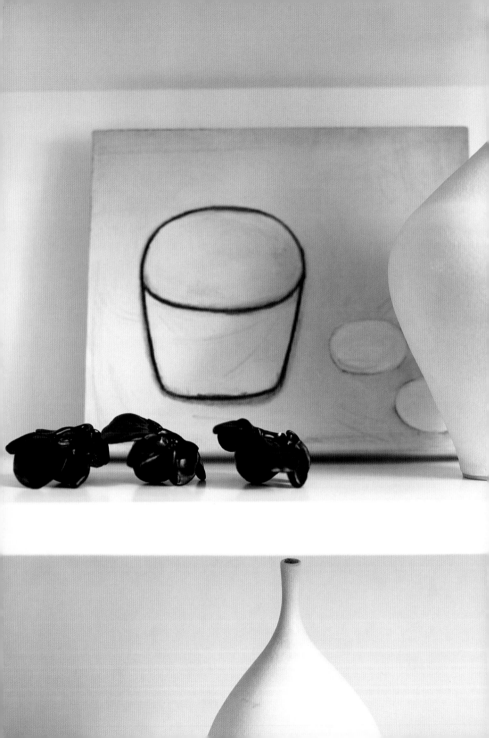

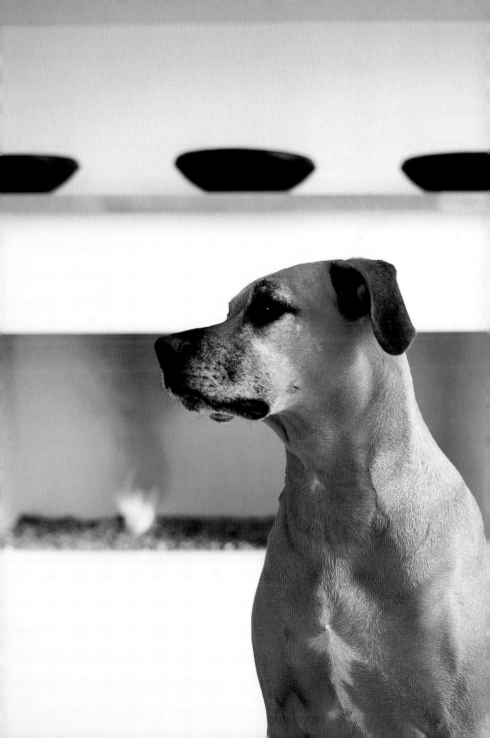

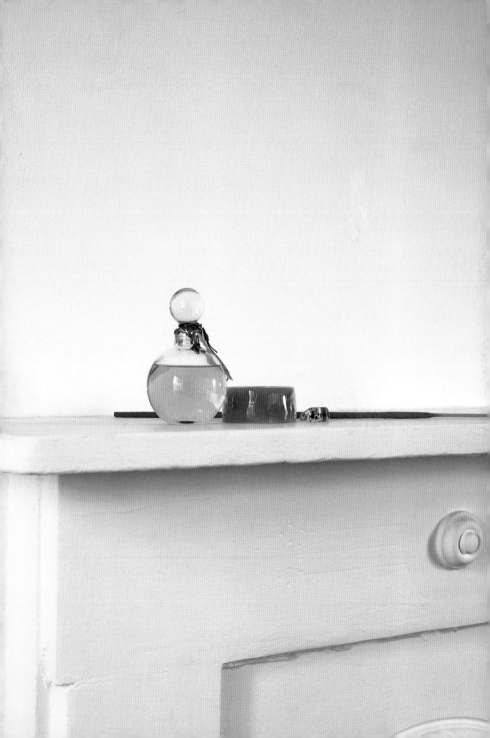

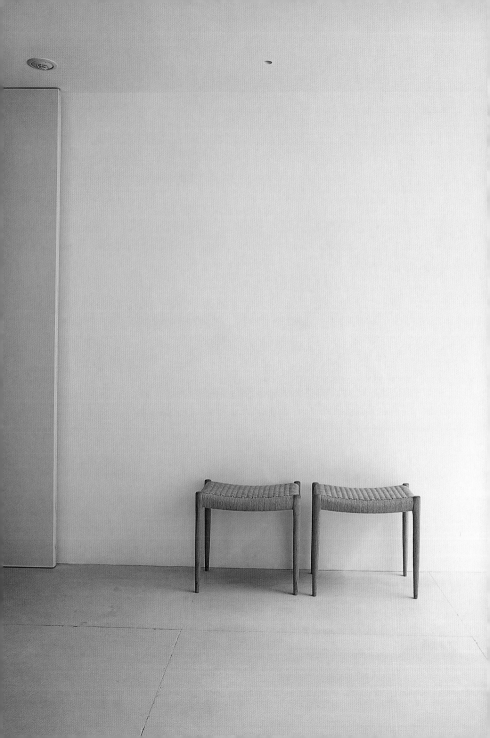

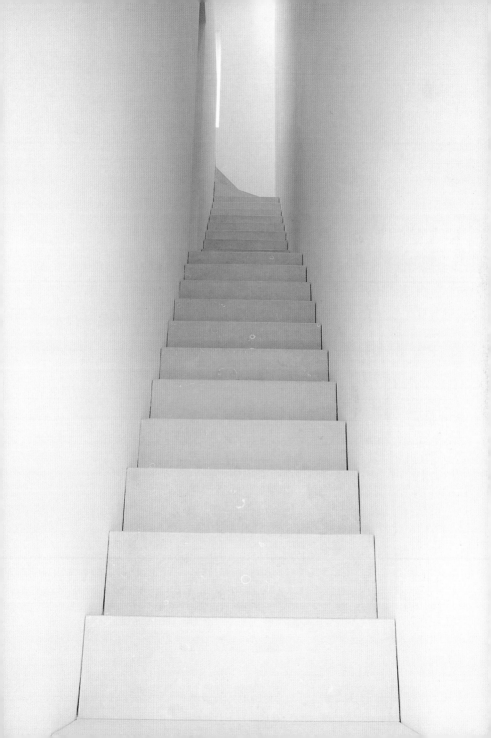

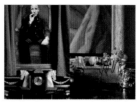
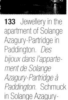
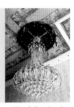

131 In the Victorian pub of H. Abdullah, M. Lasserre + S. Karlson. *Dans le pub victorien de H. Abdullah, M. Lasserre + S. Karlson.* Im viktorianischen Pub von H. Abdullah, M. Lasserre + S. Karlson.

132 Dave Courtney's portrait in the living room of his Plumstead house. *Le portrait de Dave Courtney dans le salon de sa maison à Plumstead.* Dave Courtneys Porträt in seinem Haus in Plumstead.

133 Jewellery in the apartment of Solange Azagury-Partridge in Paddington. *Des bijoux dans l'appartement de Solange Azagury-Partridge à Paddington.* Schmuck in Solange Azagury-Partridges Wohnung in Paddington.

135 Italian chandelier in Dave Courtney's Plumstead house. *Un lustre italien dans la maison de Dave Courtney à Plumstead.* Italienischer Lüster im Haus Dave Courtneys in Plumstead.

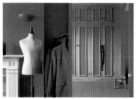

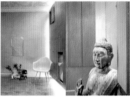

136 Fuchsia and crimson are fashion designer Boateng's trademark. *Fuchsia et cramoisi sont les couleurs fétiches de Boateng.* Fuchsia und Purpur sind die Markenzeichen des Modedesigners Boateng.

137 Dressing area in Ozwald Boateng's house on Wimpole Street. *Le dressing d'Ozwald Boateng dans sa maison de Wimpole Street.* Ankleidezimmer in Ozwald Boatengs Haus in der Wimpole Street.

139 Corner of the living room on the Thames barge, The Catharina. *Un coin du salon de The Catharina, une péniche aménagée sur la Tamise.* Wohnzimmerecke auf der Barkasse The Catharina auf der Themse.

140 Carolyn Corben practises Nichiren Daishonin Buddhism every day. *Carolyn Corben est une adepte du bouddhisme Nichiren Daishonin.* Carolyn Corben ist Anhängerin des Nishiren Daishonin Buddhismus.

141 Detail from Carolyn Corben's Clapham flat. *Détail de l'appartement de Carolyn Corben à Clapham.* Detail aus Carolyn Corbens Wohnung in Clapham.

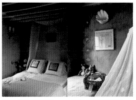
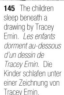

143 Interior detail from a Georgian town house. *Détail de l'intérieur d'une maison georgienne.* Detailansicht aus einem georgianischen »town house«.

144 The romantic bedroom of a Georgian town house. *La chambre à coucher romantique d'une maison georgienne.* Das romantische Schlafzimmer eines georgianischen »town house«.

145 The children sleep beneath a drawing by Tracey Emin. *Les enfants dorment au-dessous d'un dessin de Tracey Emin.* Die Kinder schlafen unter einer Zeichnung von Tracey Emin.

147 Detail from a North London town house. *Détail d'une maison du nord de Londres.* Detail aus einem »town house« im Norden Londons.

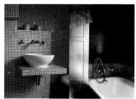

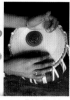

148 A bathroom decorated with modern mosaic tiles. *Cette salle de bains est décorée de carreaux de mosaïque.* Dieses Badezimmer ist mit Mosaikfliesen ausgelegt.

149 Copper sheetings surround the bath of a Georgian town house. *Des feuilles de cuivre entourent la baignoire d'une maison georgienne.* Kupferplatten fassen die Wanne eines georgianischen »town house« ein.

151 The Indian goddess of music guards the computer of Talvin Singh. *La déesse indienne de la musique veille sur l'ordinateur de Talvin Singh.* Die indische Göttin der Musik wacht über Talvin Singhs Computer.

152 Compact discs on a diaphanous curtain in Singh's living room. *Un rideau diaphane parsemé de disques compacts dans le salon de Singh.* Durchsichtiger Vorhang mit CDs in Singhs Wohnzimmer.

153 Talvin Singh's hands on his drum. *Les mains de Talvin Singh sur son tambour.* Talvin Singhs Hände auf seiner Trommel.

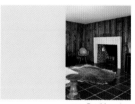

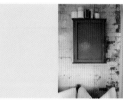

155 Detail from the living room of Ou Baholyodhin + Erez Yardeni. *Détail de la salle de séjour d'Ou Baholyodhin + Erez Yardeni.* Detail aus dem Wohnraum von Ou Baholyodhin + Erez Yardeni.

156 Shoes by shoemaker John Moore and sandals from India. *Chaussures du bottier John Moore et sandales indiennes.* Schuhe des Schuhmachers John Moore und indische Sandalen.

157 Tom + Polly Lloyd's bathroom. *La salle de bains de Tom + Polly Lloyd à Hackney.* Das Badezimmer von Tom + Polly Lloyd in Hackney.

159 Detail from the bathroom of Tom + Polly Lloyd's house. *Détail de la salle de bains de la maison de Tom + Polly Lloyd.* Detail aus dem Badezimmer im Haus von Tom + Polly Lloyd.

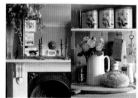

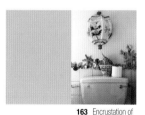

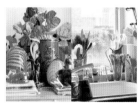

160 Detail of the living room of Judy Kleinman's Notting Hill house. *Détail du salon de la maison de Judy Kleinman à Notting Hill.* Detailansicht aus dem Wohnzimmer von Judy Kleinmans Haus in Notting Hill.

161 Flowers in Sam Robinson's kitchen. *Des fleurs dans la cuisine de Sam Robinson.* Blumen in der Küche von Sam Robinson.

163 Encrustation of shells and starfish in Sam Robinson's bathroom. *Une frise de coquillages et d'étoiles de mer dans la salle de bains de Sam Robinson.* Ein Muschel- und Seesternrelief in Sam Robinsons Bad.

164 Sam Robinson's work desk in her Notting Hill flat. *Le bureau de Sam Robinson dans son appartement de Notting Hill.* Der Arbeitsplatz in Sam Robinsons Wohnung in Notting Hill.

165 Detail from Sam Robinson's kitchen. *Détail de la cuisine de Sam Robinson.* Detail aus der Küche von Sam Robinson.

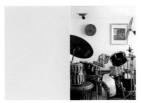

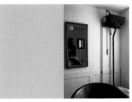

167 In the Brick Lane studio of musician and DJ Talvin Singh. *Le studio du musicien et DJ Talvin Singh à Brick Lane.* Ansicht aus dem Studio des Musikers und DJs Talvin Singh in der Brick Lane.

168 Anne Shore's front door is coated with blackboard paint. *La porte d'entrée d'Anne Shore est recouverte de peinture pour tableau noir.* Die Haustür von Anne Shore ist mit Farbe für Schultafeln beschichtet.

169 The fridge in Anne Shore's kitchen. *Le réfrigérateur dans la cuisine d'Anne Shore.* Der Kühlschrank in Anne Shores Küche.

171 The simple bathroom in Anne Shore's house. *La sobre salle de bains dans la maison d'Anne Shore.* Das einfache Badezimmer in Anne Shores Haus.

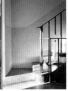

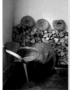

172 Provençal terracotta pots on Shore's terrace in Spitalfields. *Des pots en terre cuite provençaux sur la terrasse de Shore à Spitalfields.* Provenzalische Terrakottatöpfe auf Shores Terrasse in Spitalfields.

173 Stone staircase in a Victorian house in the East End. *L'escalier en pierre d'un bâtiment victorien dans le East End.* Steintreppe in einem viktorianischen Haus im Londoner East End.

174 Shore's dining room with "Cherner" chair by Paul Goodman and firewood. *La salle à manger de Shore avec la chaise «Cherner» de Paul Goodman et des bûches empilées.* Shores Esszimmer mit dem »Cherner«-Stuhl und Feuerholz.

176 In the kitchen of Talvin Singh. *Dans la cuisine de Talvin Singh.* In der Küche von Talvin Singh.

177 Florence, the daughter of Nick Hastings + Denise Hurst. *Florence, la fille de Nick Hastings + Denise Hurst.* Florence, die Tochter von Nick Hastings + Denise Hurst.

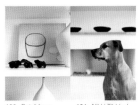

179 Colour photocopies cover Carolyn Corben's bedroom walls. *Les murs de la chambre de Carolyn Corben sont tapissés de photocopies couleur.* Fotokopien bedecken die Wände von Carolyn Corbens Schlafzimmer.

180 Detail from Nikki Tibbles' flat. *Détail de l'appartement de Nikki Tibbles.* Detail aus der Wohnung von Nikki Tibbles.

181 Nikki Tibbles' dog. *Le chien de Nikki Tibbles.* Nikki Tibbles' Hund.

183 Detail of the living room of Judy Kleinman's Notting Hill house. *Détail du séjour de la maison de Judy Kleinman à Notting Hill.* Detailansicht aus dem Wohnraum von Judy Kleinmans Haus in Notting Hill.

184 Scandinavian kitchen stools in the Pawsons' house. *Deux tabourets scandinaves dans la maison des Pawson.* Zwei skandinavische Küchenhocker im Haus der Pawsons.

185 Staircase in John + Catherine Pawson's house. *La cage d'escalier dans la maison de John + Catherine Pawson.* Treppenhaus in John + Catherine Pawsons Haus.

ACKNOWLEDGEMENTS / REMERCIEMENTS / DANKSAGUNG

We would like to thank everyone who let us into their lives and all those along the way who have given their time, invaluable contacts and leads, advise and encouragement.
Thank you to: Sadie Coles, Charles Asprey, Simon Upton and Karen Howes at The Interior Archive, Katy Baggott, Catherine Scott, Sarah Delaney, Charlotte + Peter Fiell, Alison Edmond, Jenny Lin, Luisella Burrow, Lionel de Rothschild, Stephanie Hale, David Carter, William Richards + Chris Mizeika, Alex de Rijke, Patrick Whittaker, Oriel Harwood, Audrey Carden, Anthony Easton, Roger Bevan, Peter St.John, Penny Govette, Maria Grachvogel, Stephen Mayle, Paul Daly, Mel Agace, Tom Conran, Ken Hayden, Mathew Williamson, Tardis Studios + Nick Reynolds, Softroom, Rana Salam and Sean at FAT.

The Hotel Book.
Great Escapes South America
Ed. Angelika Taschen
Hardcover, 360 pp. / € 29.99 /
$ 39.99 / £ 24.99 / ¥ 5.900

The Hotel Book.
Great Escapes North America
Ed. Angelika Taschen
Hardcover, 400 pp. / € 29.99 /
$ 39.99 / £ 24.99 / ¥ 5.900

The Hotel Book.
Great Escapes Asia
Ed. Angelika Taschen
Hardcover, 400 pp. / € 29.99 /
$ 39.99 / £ 24.99 / ¥ 5.900

"This is one for the coffee table, providing more than enough material for a good drool. Gorgeousness between the cover." —*Time Out*, London, on *Great Escapes Africa*

" Buy them all and add some pleasure to your life."